ICHTHYO

ICHTHYO

THE ARCHITECTURE OF FISH

X-Rays from the Smithsonian Institution

By Stephanie Comer and Deborah Klochko

Essays by Jean-Michel Cousteau, Dr. Daniel Pauly, and Dr. Lynne R. Parenti

X-Rays by Sandra J. Raredon

CHRONICLE BOOKS
SAN FRANCISCO

in association with the Smithsonian Institution,

National Museum of Natural History, Washington, D.C.

Library of Congress Cataloging-in-Publication Data available.

ISBN: 978-0-8118-6192-2

Manufactured in China.

Designed by Studio Italics (Irene Rietschel and Michael Read)
Digital image enhancement by Michael Rauner

10 9 8 7 6 5 4 3 2 1

Chronicle Books LLC
680 Second Street
San Francisco, CA 94107

www.chroniclebooks.com

CONTENTS

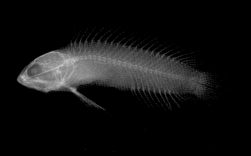
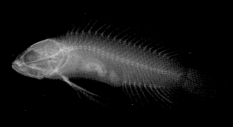

$$\frac{6}{7}$$

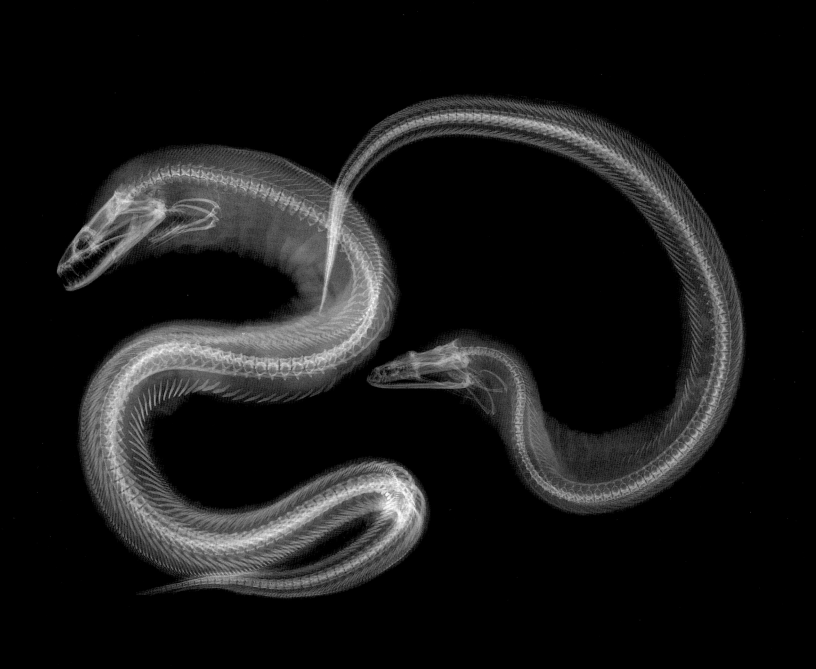

IMAGES OF SCIENCE

Stephanie Comer
Deborah Klochko

Art is science made clear.
—Jean Cocteau, 1926

There is a beauty to science, and a science to the beauty inherent in art. From the beginning, art and science have been inseparable—art, like science, is about inspiration and the pursuit of new ideas. As Isaac Asimov wrote, "How often people speak of art and science as though they were two entirely different things, with no interconnection . . . The true artist is quite rational as well as imaginative and knows what he is doing; if he does not, his art suffers. The true scientist is quite imaginative as well as rational, and sometimes leaps to solutions where reason can follow only slowly; if he does not, his science suffers." Both art and science are necessary in the drive to understand and interpret the world, to fulfill the insatiable need to make sense of what is around us.

The Scientific Revolution of the sixteenth and seventeenth centuries gave rise to a new way of thinking. Direct contact with nature through observation and experimentation replaced the practice of relying on ancient theories. Knowledge was no longer finite, but open to limitless possibilities. Along with the quest for new information, methods based on an enlightened perspective were devised to render nature.

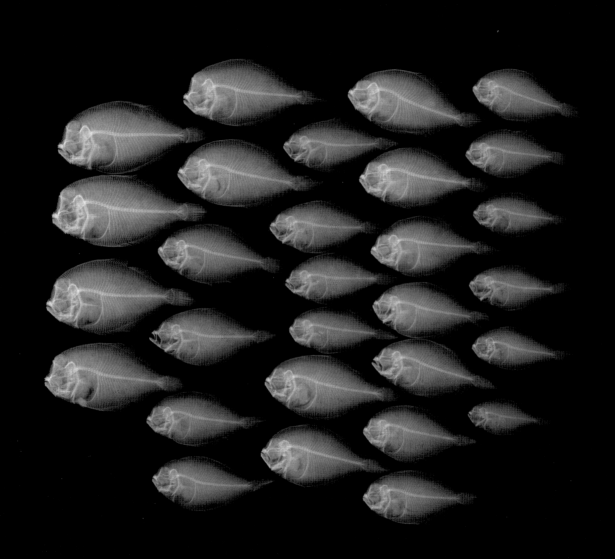

Exact descriptions, along with an understanding of both form and function, became important in establishing new interpretations of nature.

For centuries, scientific illustrations were used to portray the wonders of the natural world. The age of enlightened thinking brought about by the Scientific Revolution inspired the creation of new tools of observation that allowed artists to depict nature realistically. Devices like the microscope and telescope allowed scientists to see things the human eye could not. Worlds within worlds were revealed, from the wing of an insect to the surface of the moon.

When photography was invented in the early part of the nineteenth century, it was embraced, not only as an aid for gathering information but as a tool for depicting what the eye could not see without assistance. Photography developed out of both scientific and artistic pursuits, at a time when explorations into optics, chemistry, and perception came together to create a means of accurately recording the exciting discoveries being made. In 1895 the discovery of Röntgen rays, or X-rays, made it possible to capture the intimate inner workings of animals and objects on film.

Founded in the mid-1800s, the fish collection at the Smithsonian Institution's National Museum of Natural History is the world's largest, containing approximately 540,000 lots and nearly 3.5 million specimens. The museum's ichthyology department now produces digital X-rays that utilize the latest scientific advances to create images of the delicate bones of fish. The images are the modern equivalents of the earlier, handmade—but equally beautiful—renderings used in scientific study. These evocative and detailed X-rays, comparable to fine engravings, represent an ideal marriage of art and science.

In his forty-four-volume *Histoire Naturelle,* the eighteenth-century French naturalist Georges-Louis Leclerc, Comte de Buffon, wrote, "Natural history embraces all the objects which are presented to us by the Universe." These striking images demonstrate just how beautiful the universe can be. ■

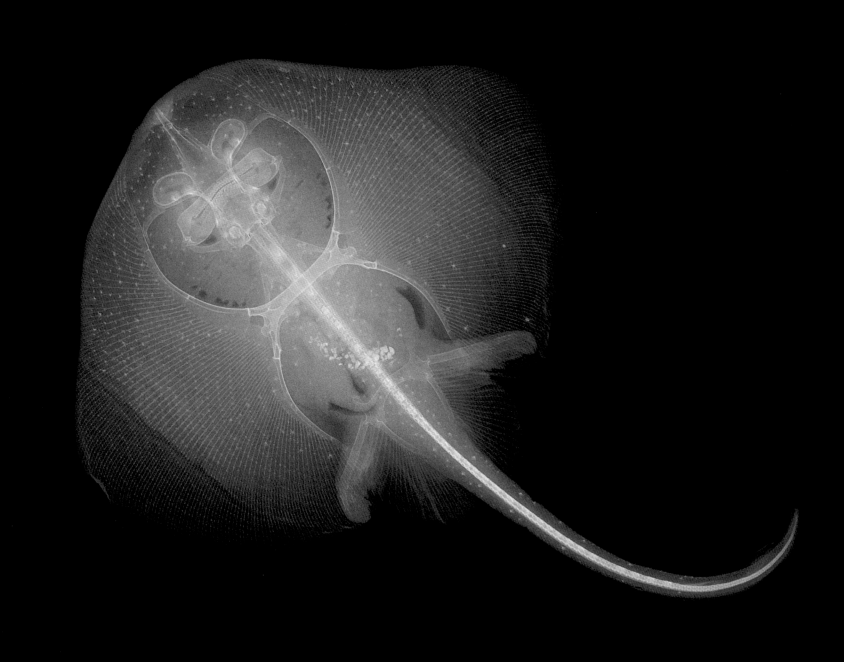

ICHTHYO

Jean-Michel Cousteau

As much as my family name is associated with ocean explo-
ration and preservation, my formal education is in architec-
ture. Rarely do my love of the sea and its creatures and my
fascination with structure combine in a single work. *Ichthyo*
is such a work.

This book joins art and science to capture the exciting reve-
lations technology provides when we apply it in unexpected
ways. Most important, it changes our minds about things
we have always taken for granted, or simply not known.
These digital X-rays pry into the structure of life in a liquid
medium and are as informative as they are startling.

To many of us, a fish is a fish is a fish. But, in the broadest
sense, humans have an evolutionary connection to fish. Fish
were the first animals to have backbones some 450 million
years ago. Human embryos first form a fish kidney. The
plumbing from this fish kidney becomes the fallopian tubes
in human females and the sperm ducts in males. The gill
arches of ancient fish gave humans articulating jaws and
became the bones that transmit movements of the eardrum

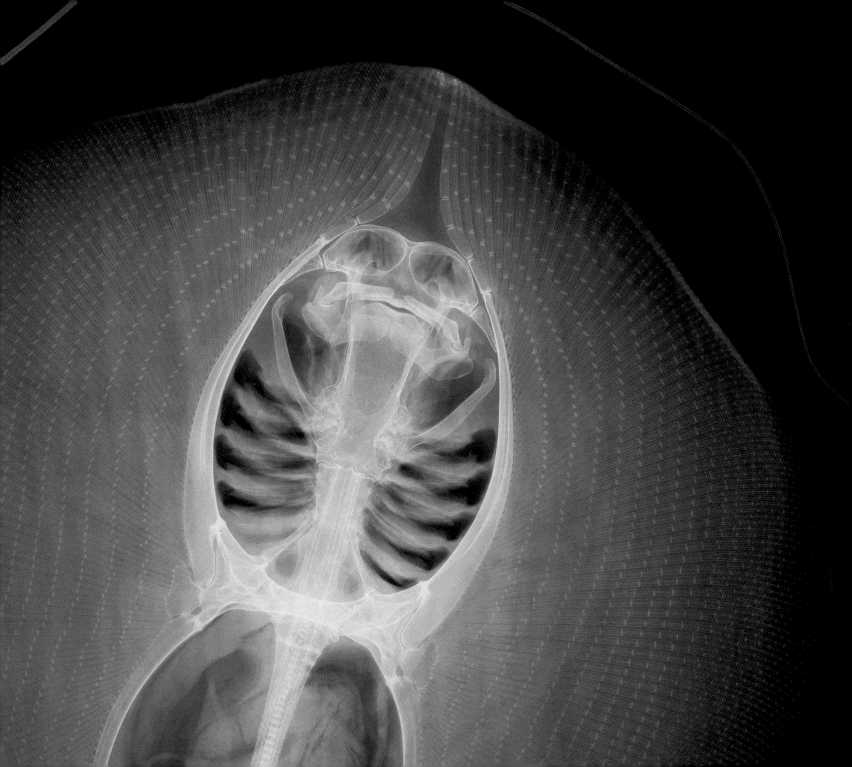

to the inner ear where sound is perceived. And, of course, fish left the sea to take up four-footed existence on land. Fish are our ancient—but not so foreign—relatives.

Amazingly, much of how a fish behaves is discernible by knowing its structure. In this book, stories unfold through images that show the delicacy of bone and its intricate arrangement in service to the living creature. A fish with a diminished tail, for example, often has a large mouth—it can't chase its prey, but can fatally surprise it with a gulp. The links between form and function are dramatized in the dense aquatic medium. Fast-swimming fish, both sharks and bony fish, and even mammals, converge to a common fusiform, a cigarlike shape that reduces resistance and drag. The fastest submarines conform to this shape.

After sixty years of diving and exploring the waters of our planet, I continue to marvel at the diversity with which life expresses itself. I have concluded that to live the way we do, it is necessary to deny the miracles around us. Fish are an example.

We now know that 90 percent of commercially harvested large fish species are gone from the sea as a result of overfishing. A 2005 report by the United Nations Fisheries and Agriculture Organization indicates that 76 percent of commercially exploited fish populations are being harvested at or beyond their sustainable level. I am forced to conclude that we are doing everything in our power to eliminate fish from the sea. We destroy habitats where fish reproduce, dam rivers where salmon breed, remove mangroves and wetlands that are nurseries for coastal fish, and use explosives on coral reefs. We catch species we don't want and then throw them away. And the thing that horrifies me most is that we catch sharks, cut off their fins for soup, and then toss them back alive to sink and die.

There are new and equally worrisome aspects of our involvement. It is evident that human-induced sound is having an impact on life in the sea. The effect on deepwater and other marine mammals of the Navy's emission of low- and mid-range sonar frequencies is deadly. Dolphins are washing onshore, bleeding internally from the

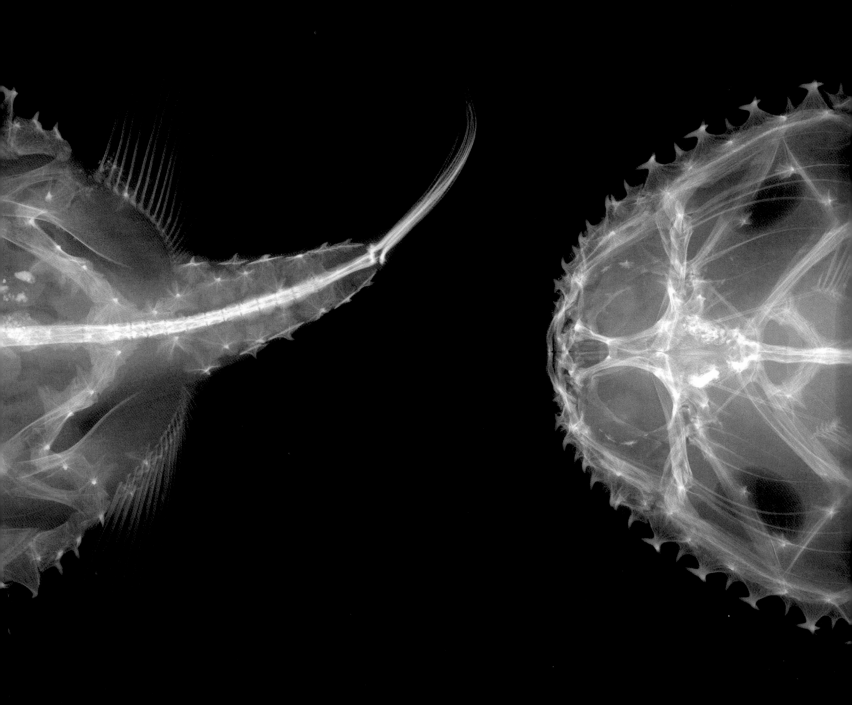

effects. We know fish and other animals communicate and perceive their environments through sound.

Amazingly, new research shows that fish larvae, surprisingly good swimmers, may choose a reef on which to settle by the sounds it emits. Sound travels in water irrespective of how the currents flow, and a community of fish can create a clamor heard 15 kilometers around a reef. At dusk and dawn, this reef cacophony crescendos, the equivalent of thousands of individual instruments in an aquatic concert. We, however, are changing that.

In spite of all that concerns me about our impact on the ocean system, I remain optimistic. People around the world are beginning to see the wisdom of establishing marine protected areas. Many reserves now have populations of fish that have restored themselves, producing young and even adults that move out into unprotected areas in a "spillover effect" that is improving fishing adjacent to the reserves.

But none of these things happen without the motivation that comes from inspiration, and the truth is that art inspires us. While we need the basis in fact that science works hard to provide, our actions move in the direction of our inspiration. Looking at these images fills me with awe and energy. The delicacy, the mastery of design, the informed intelligence of these designs of nature are simply too amazing to be ignored or mistreated.

To know which direction our actions must take, we need to be informed, and the story of our planet is that of evolving information as more and more species changed and diversified, each carrying in its genes information unique to that species. I see a species as a library of information about survival and strategies that enable that particular species to meet the challenges of life. The genes in a human, or a salmon, shark, or pufferfish, and the information these genes contain have directed the construction of our bodies and provided us with the anatomical, biochemical, and behavioral tools we need. Although the bodies of each individual die, the information remains in their offspring.

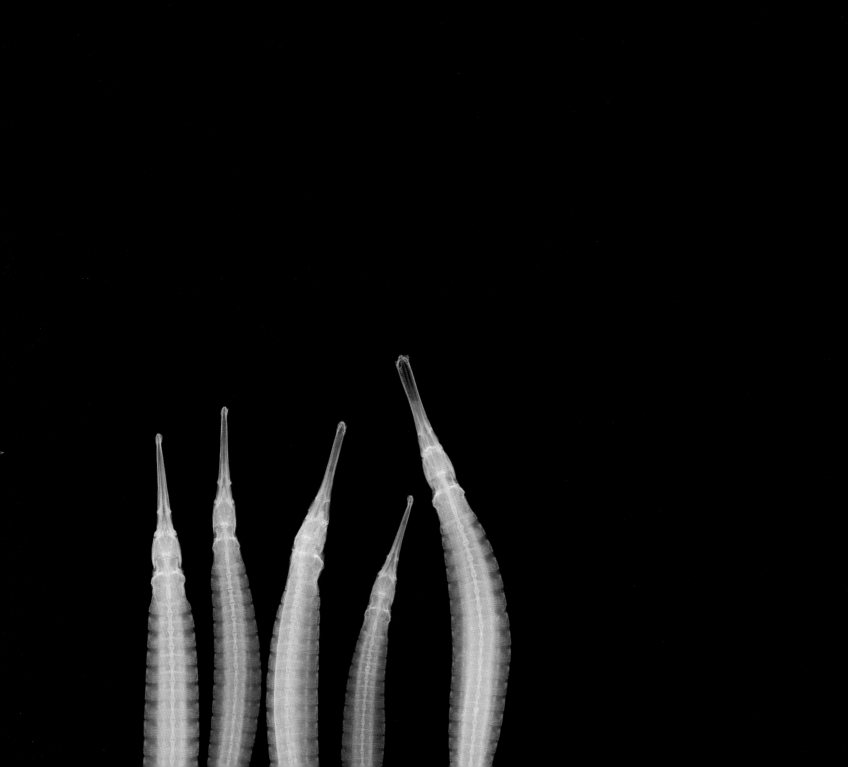

And as these fish, or any organism, adapt to changing conditions, so the information is refined, revised, and updated.

All this stops when a species goes extinct. When the last fish of an endangered species dies, the last copy of a book containing that information is lost forever. In a literal sense, the Smithsonian Institution fish collections are a vast library. Even though the fish are preserved, they provide critical references to help us differentiate one species from another and help us understand what we are trying to protect and manage.

In the sea, as everywhere on earth, everything is connected. Vast webs of interconnected life keep our planet alive and habitable for each of us. Fish are part of that web, and *Ichthyo* gives us this unprecedented view deep into component parts. ■

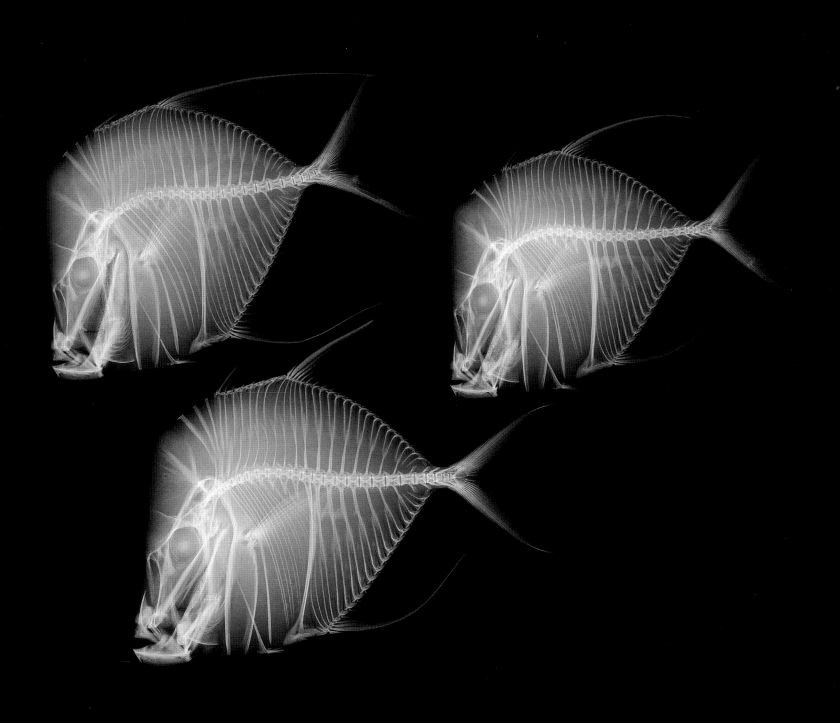

BEAUTY FOR FISHES

Dr. Daniel Pauly

Beauty may be in the eye of the beholder, but there is more to beauty than subjective whimsy. In the Renaissance, beauty—following notions dating from ancient Greece—was thought to result from certain numbers or ratios, for example the golden ratio or divine proportion (1.618 . . .) observed in many biological structures. By identifying these numbers or ratios in the shape of living organisms, including humans, we could thus access the mind of God and celebrate his sense of beauty.

Beauty and Evolution

These notions held sway until 1859, when Darwin's *Origin of the Species* appeared. *Origin* allowed us to see, when viewing an organism, not a creature (an organism created), but an evolved being. In this and subsequent work, Darwin also enabled us to see beauty as an evolved by-product of either natural or sexual selection. Both are the legacy of ancestors, which, having secured fertile mates, successfully reproduced, that is, produced offspring capable of securing a fertile mate, and so on.

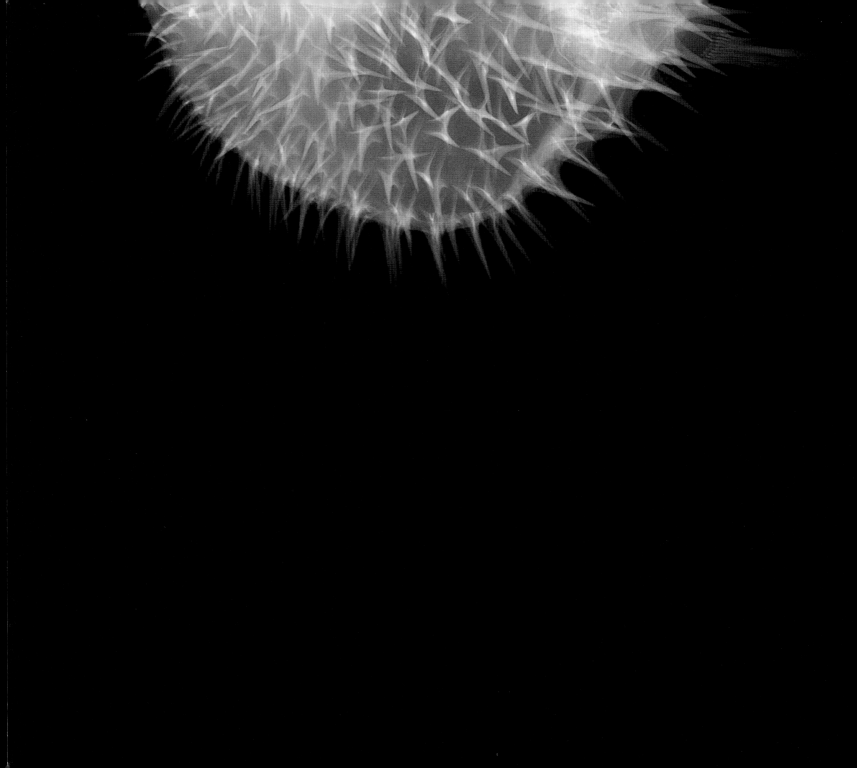

In animals, natural selection both generates and requires a sense of beauty, which is used for choosing mates. For females in particular, it is important that they choose correctly, given that in most species, producing offspring is quite costly. Moreover, neither male nor female can predict the conditions to which their offspring will be exposed. It is better, therefore, to avoid extreme traits and adaptations.

Animals, including us, do this by "averaging" the features of their potential mates and extracting a mean. Those with the features closest to this mean are seen as beautiful and desirable. They are less likely to be subject to external evolutionary pressures and more likely to survive. This is well documented in humans, and also in animals such as butterflies and fish, which have a sense of beauty and beautiful visions of prospective mates in their little brains. Thus, evolutionary success leads us to believe that "beauty is but skin deep."

The implication is that beyond the surface integument of organisms, all there is to be seen is ugliness. This is suggested in predictable TV shows, where the jaded medical examiner shocks rookie cops with the horrors of an opened-up body. But there are other ways of looking behind the skin, notably the discovery of X-rays in 1895 by Wilhelm Conrad Röntgen. X-rays make accessible to our eyes the internal structure of organisms, their symmetries, and the pattern of their lives.

Pattern Recognition: Evolution and Beauty

We enjoy discovering patterns in images and data, particularly when they are extracted from noisy background data. The reason, obviously, is that we evolved that way, as discovering patterns increased one's chance of survival. For example, patterns in the soil reveal the presence of edible roots, and the flight patterns of vultures indicate the location of a meaty carcass at the horizon.

Our pattern recognition system, however, is not honed to any specific patterns, and this enables us to appreciate patterns that have no survival value in evolutionary terms— hence our appreciation of the arts. A symphony is layered,

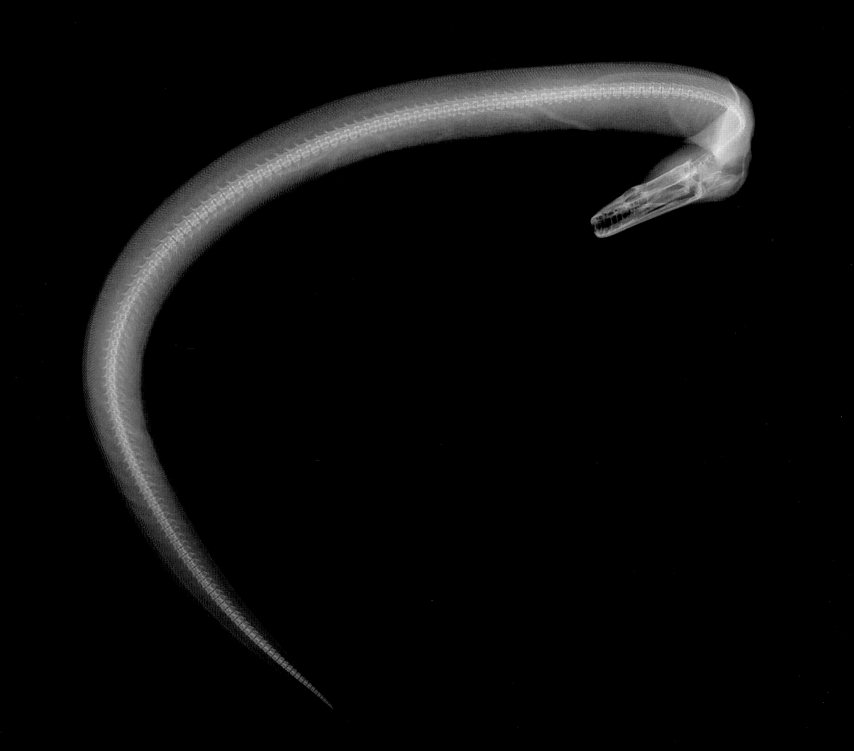

and the recognition of one pattern leads to the recognition of another, deeper pattern: pattern upon pattern, an endlessly layered onion. It is the same for the X-rays of the fish in this book.

What do we see when we look at these fish? We see symmetries, always bilateral, often complex. For example, a flying fish (see page 81) has bilateral symmetry and two pairs of wings, like a bird riding on a bird. Then we see the repetitive pattern of the ribs, some, but not all, continued in fin rays. These are in groups—the dorsal might consist of two sets of rays, and the anal fin reproduces only part of that pattern.

Beyond the symmetries and patterns, we gradually discern functions: a head with strong jaws to grasp strong prey or, on another fish, long buccal tubes with a tiny mouth at the end. Their owner surely eats little things. We begin to see the body as an afterthought, following on the mouth. These fish live only to eat, especially as the X-rays do not see the gonad that will produce the next generation of these voracious creatures.

Beauty is not skin deep. It is accessible through any of the onion's layers, with the internal layers informing those outside of the beauty inside. Also, beauty in animals is embodied in symmetries, which lead their possessors to be selected and their genes to be passed along in the course of evolution.

And no, beauty is not in the eye of the beholder. It is, if anywhere, in our brains, which reward us with finding patterns and symmetries, the art in the science of this collection of fish, and in this book. ■

PLATES

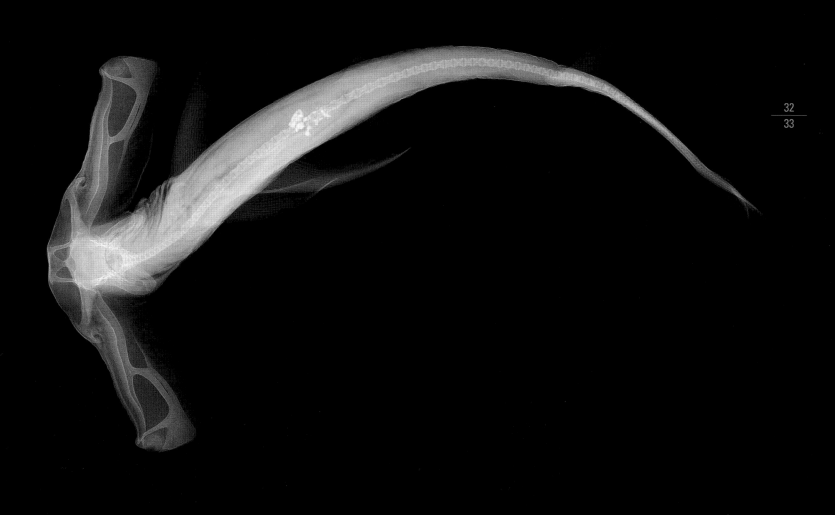

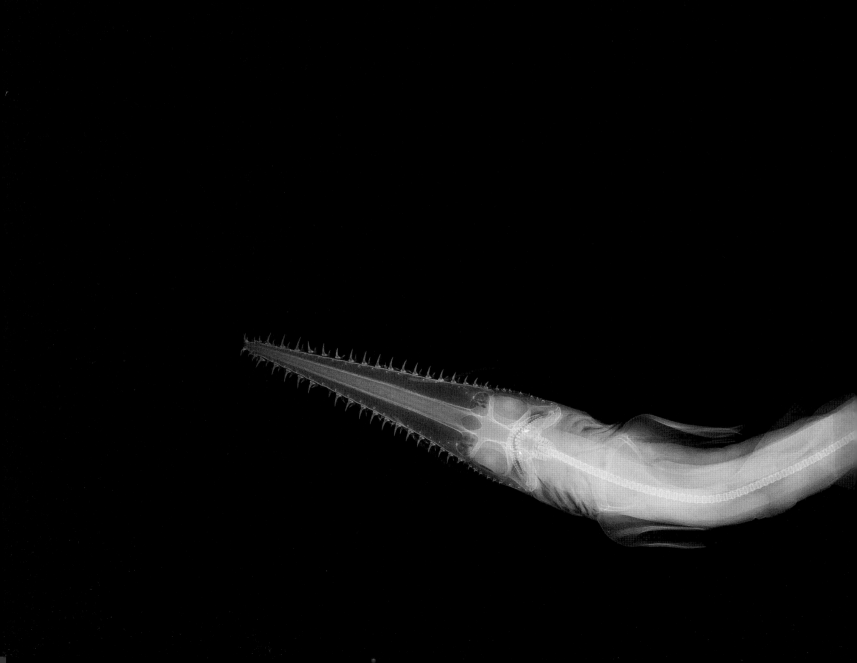

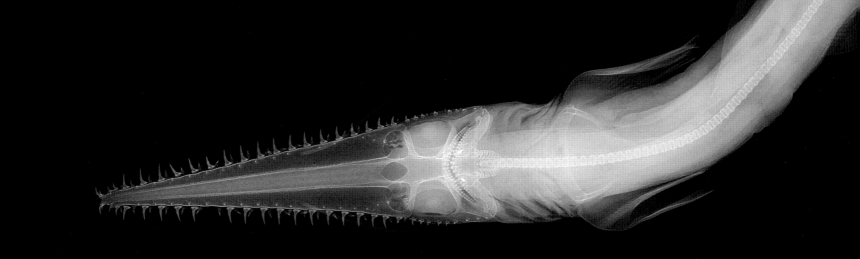

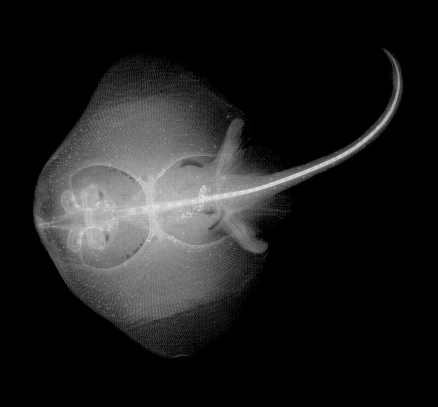

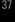

The most beautiful emotion we can experience is the mystical. It is the power of all true art and science.

—ALBERT EINSTEIN, 1947

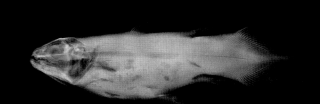

40

41

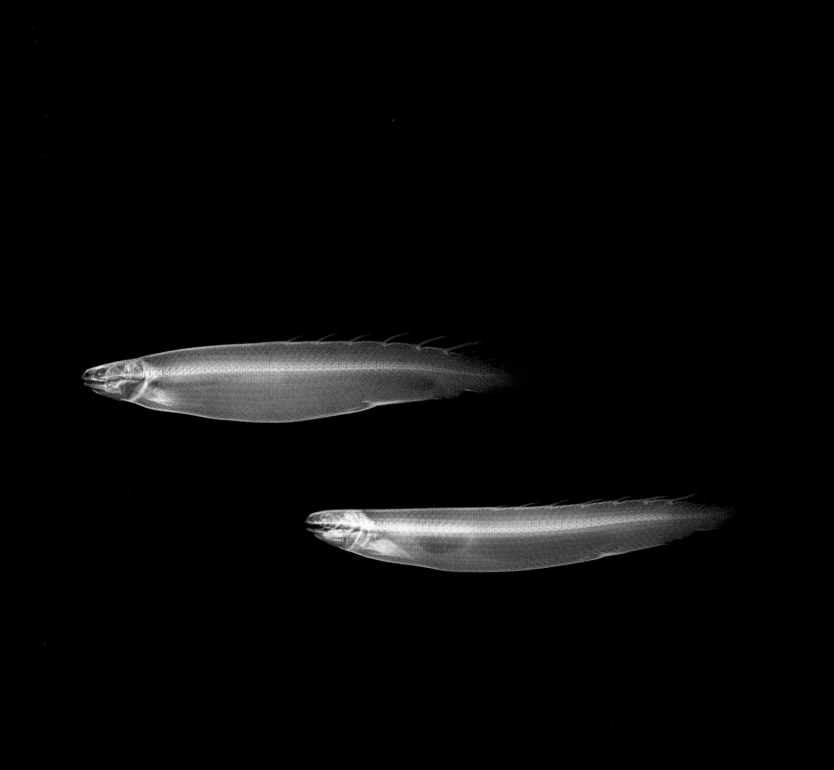

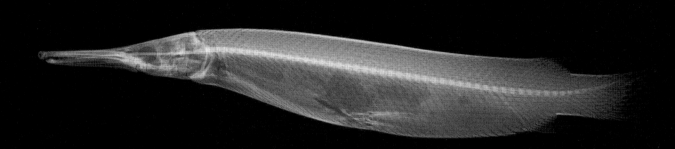

42
43

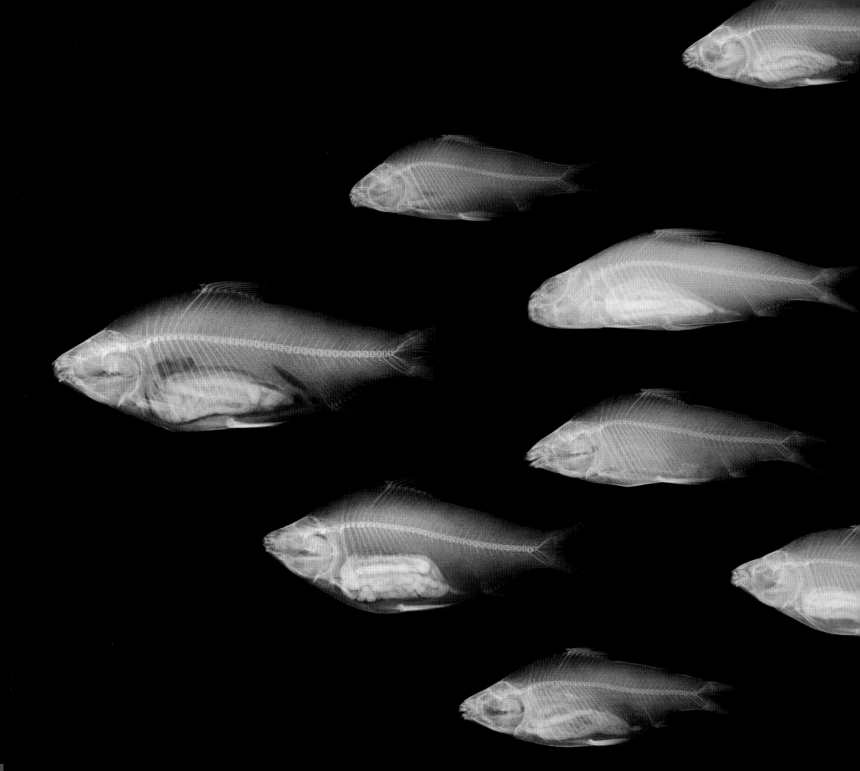

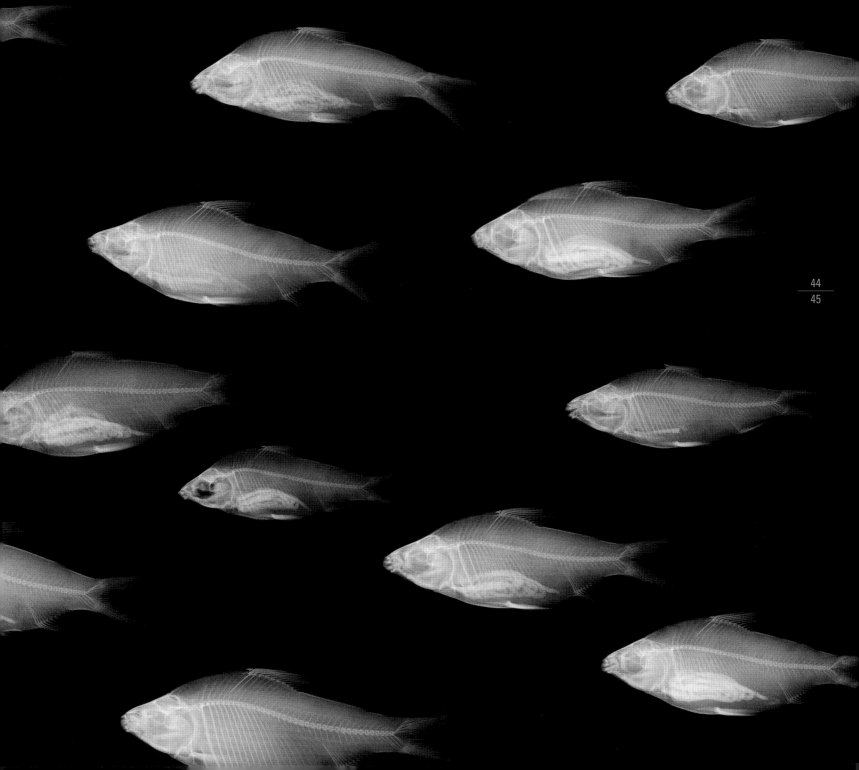

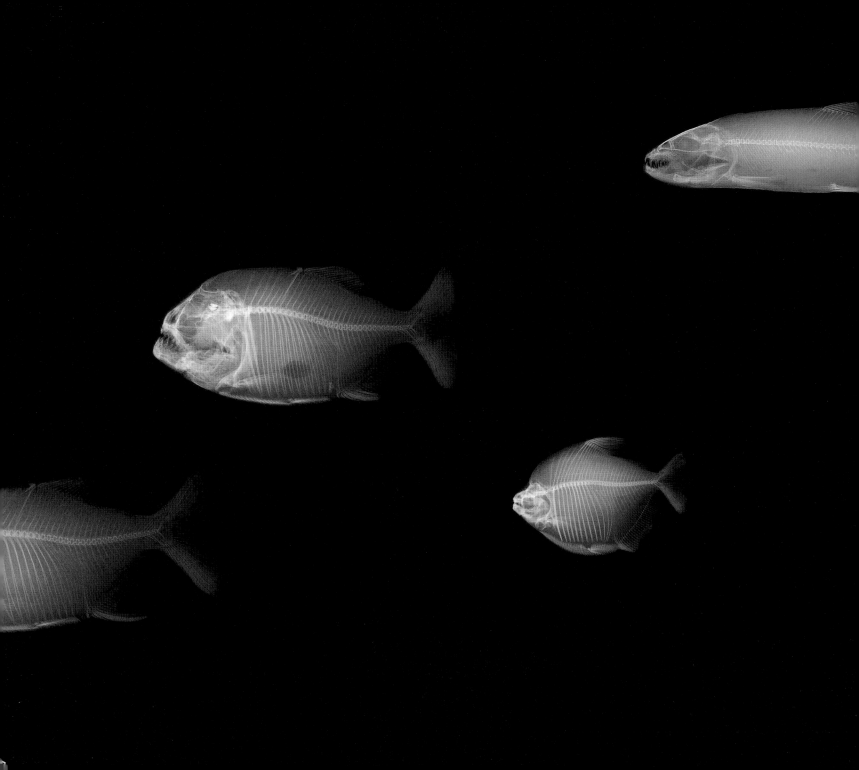

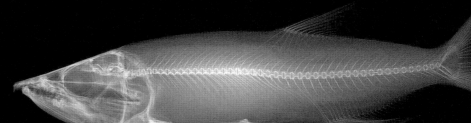

Big fish eat small fish,
and small fish eat shrimp eggs.

—CHINESE PROVERB

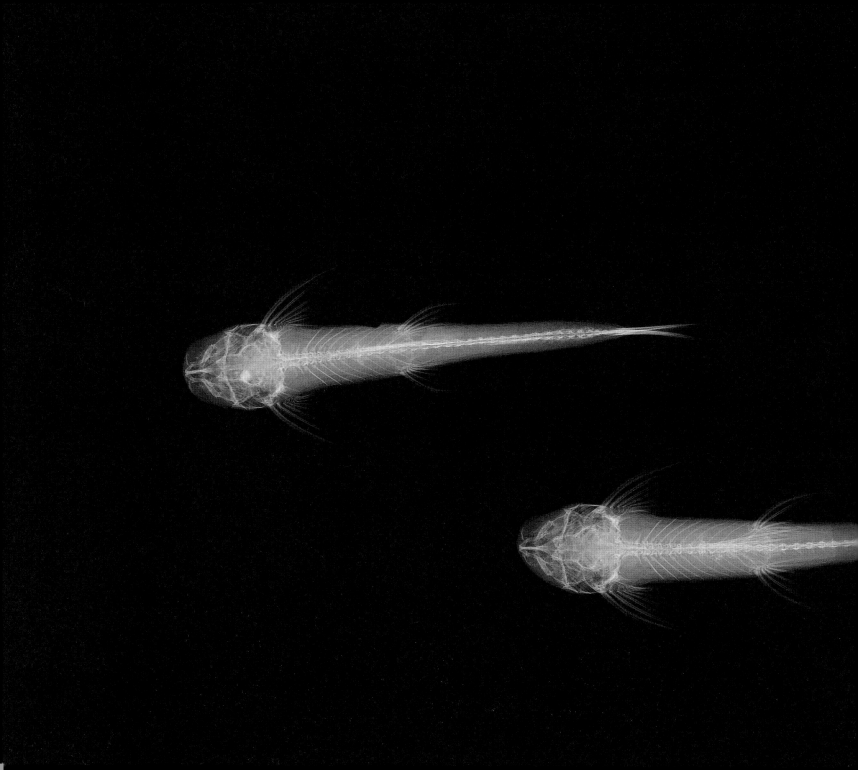

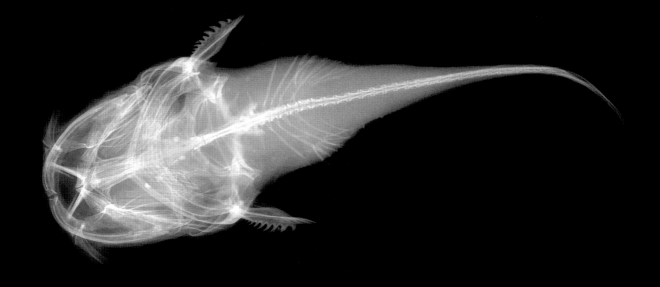

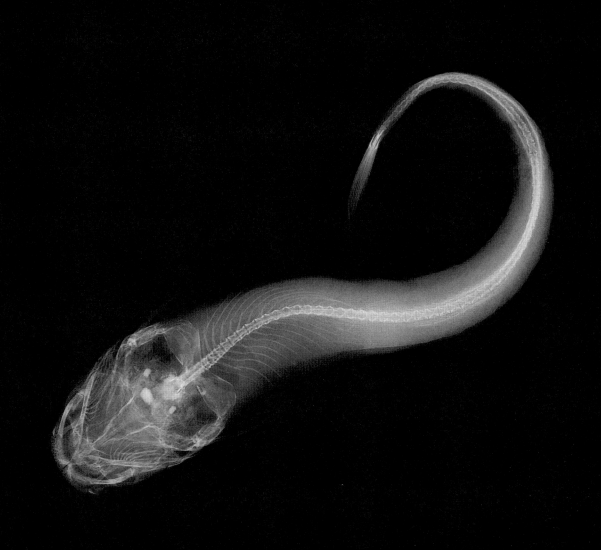

$$\frac{54}{55}$$

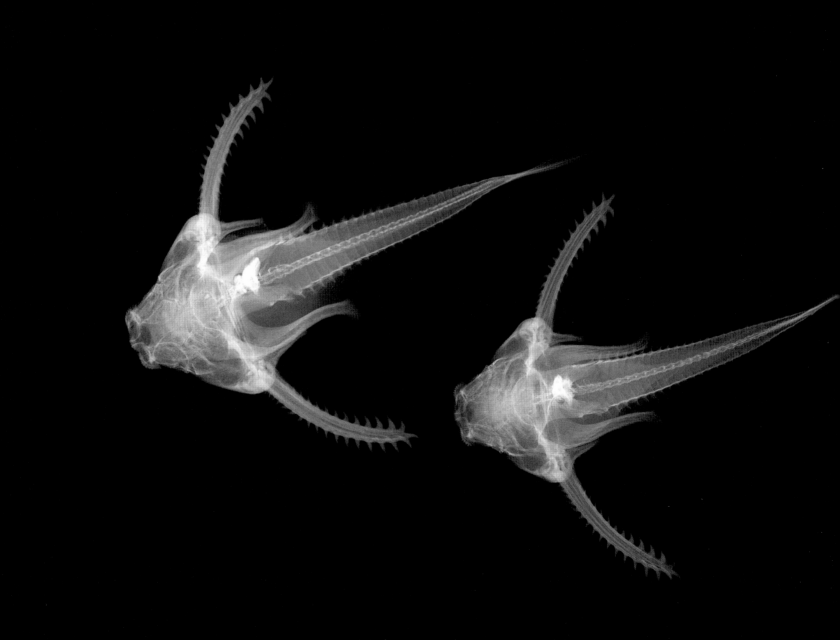

56
57

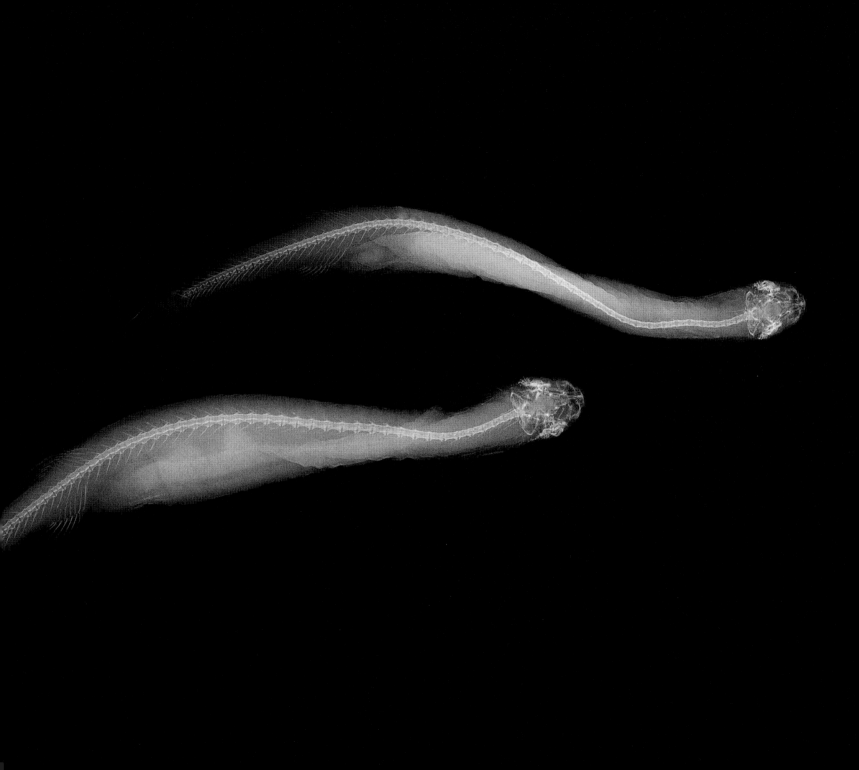

$$\frac{60}{61}$$

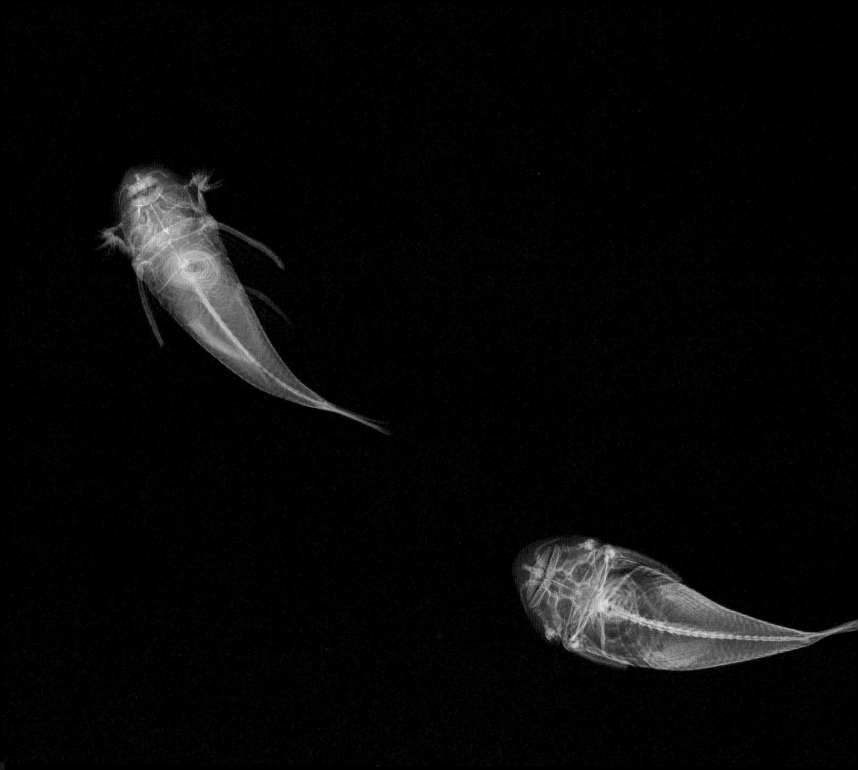

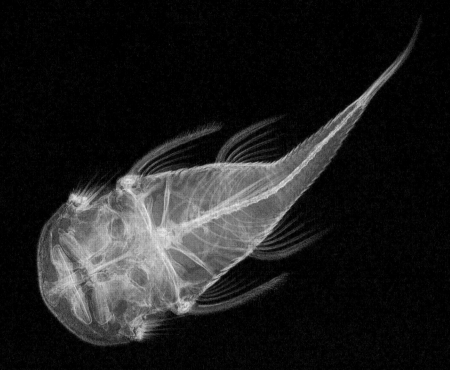

If fishes were wishes the ocean
would be all of our desire.

—GERTRUDE STEIN, 1922

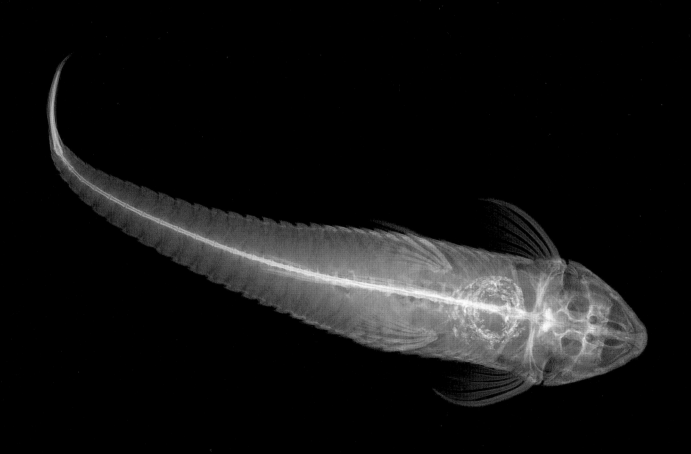

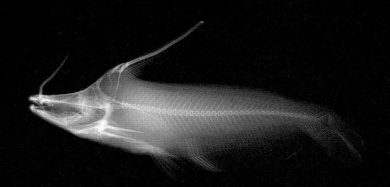

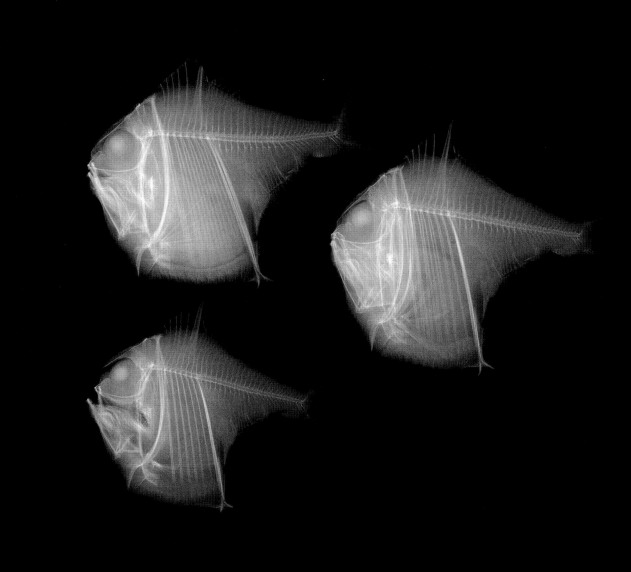

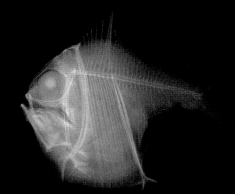

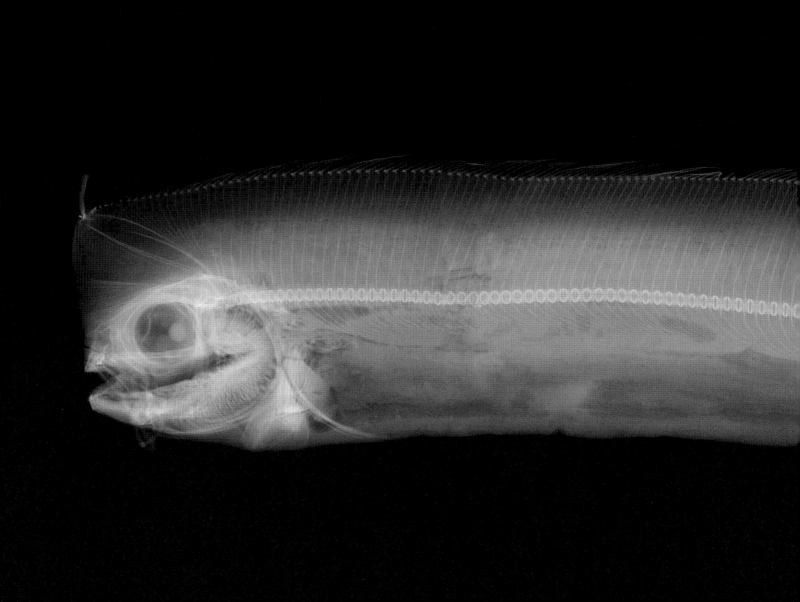

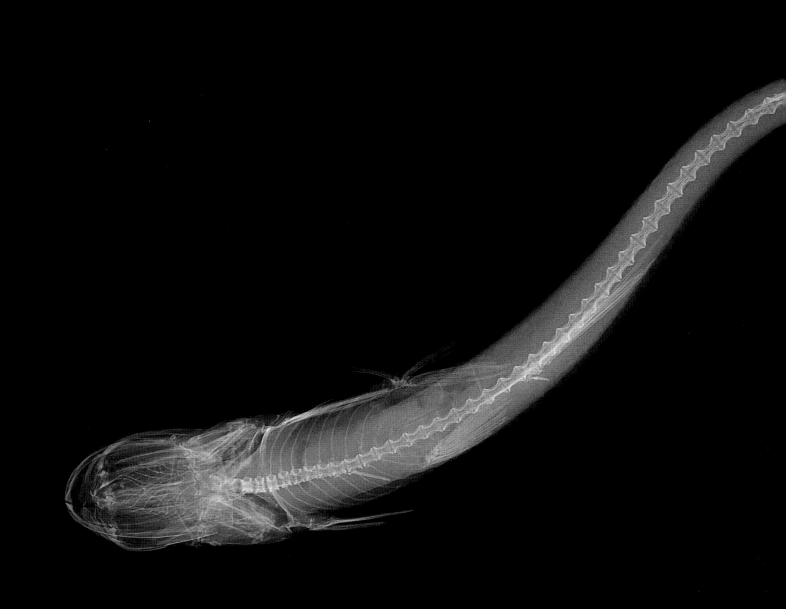

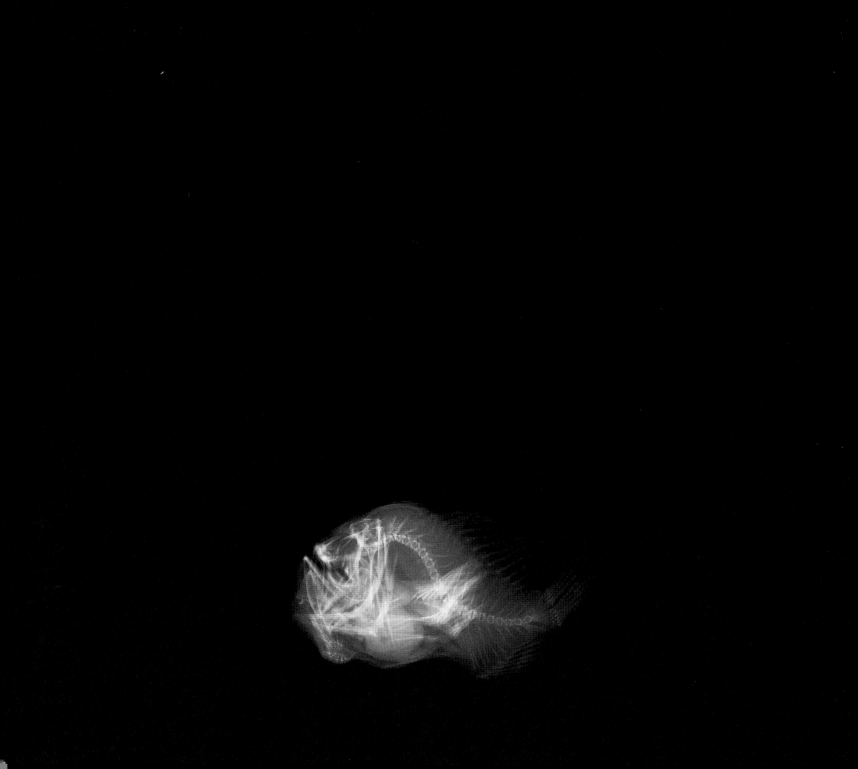

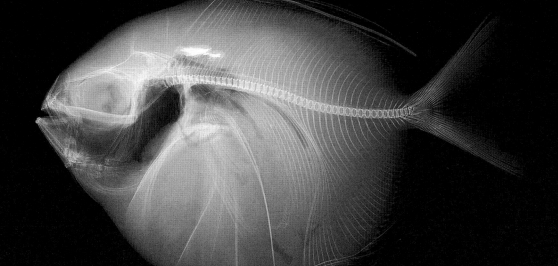

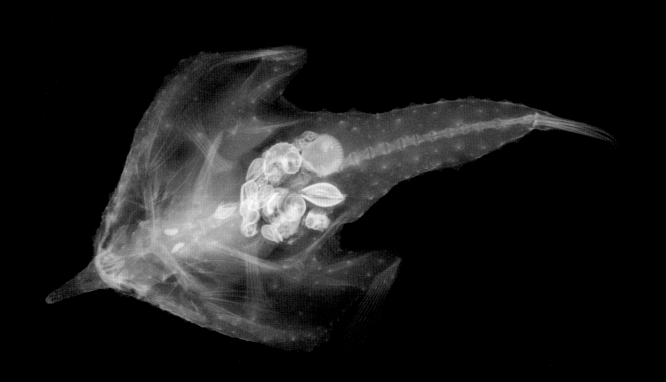

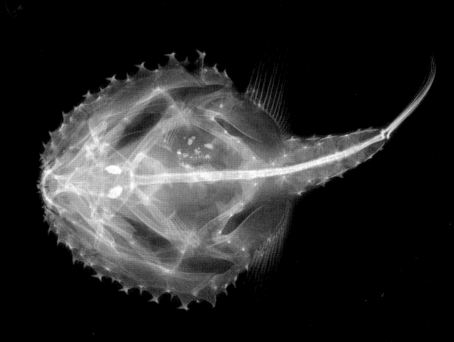

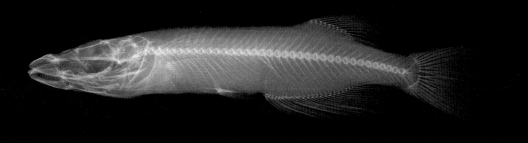

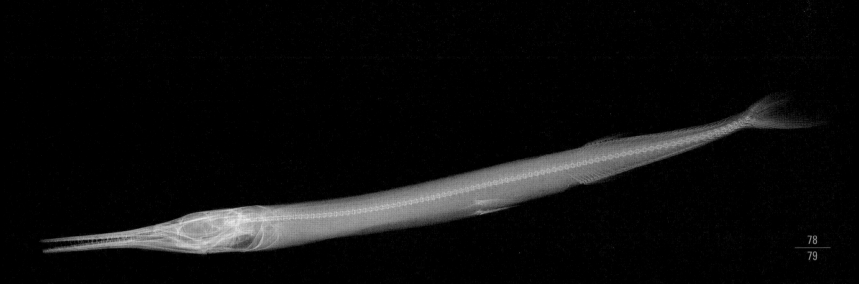

Who hears the fishes when they cry? It will not be forgotten by some memory that we were contemporaries.

—HENRY DAVID THOREAU, 1849

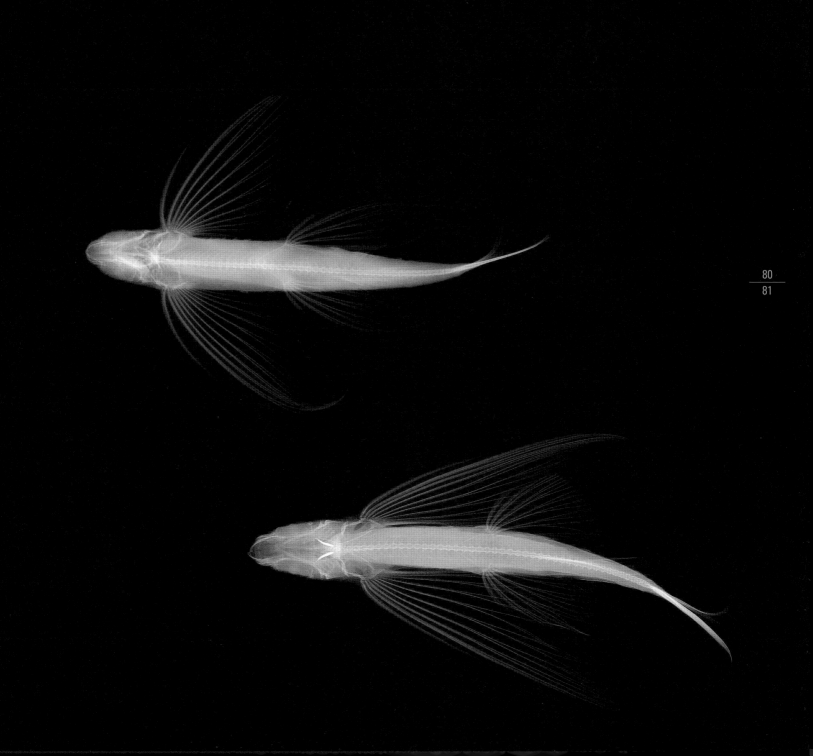

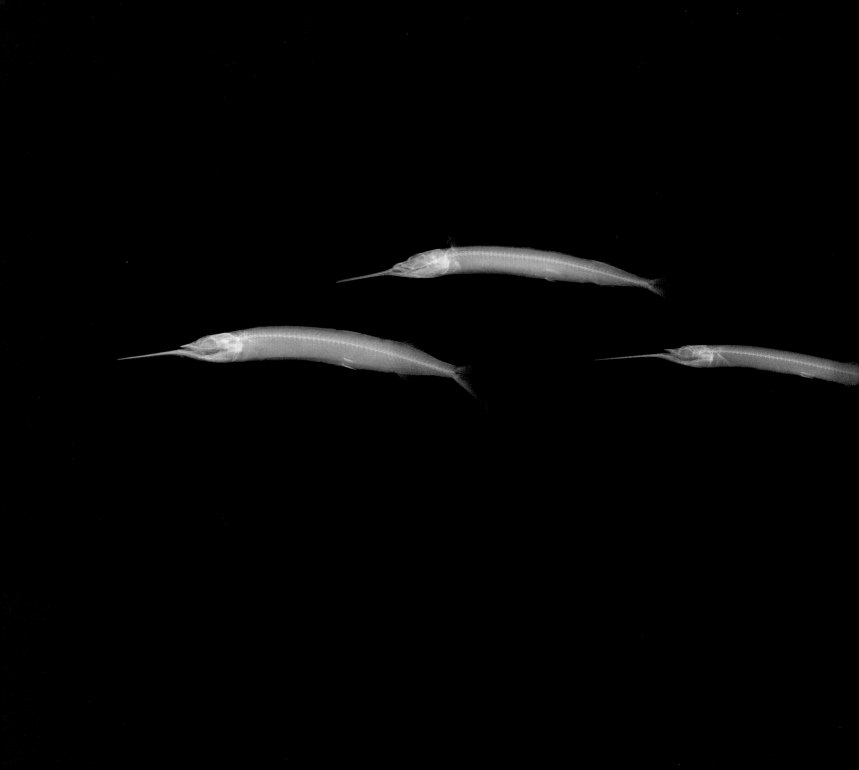

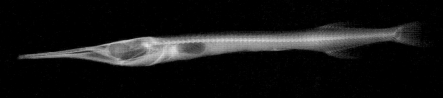

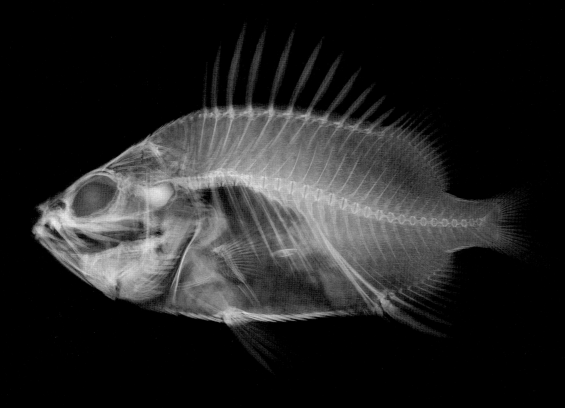

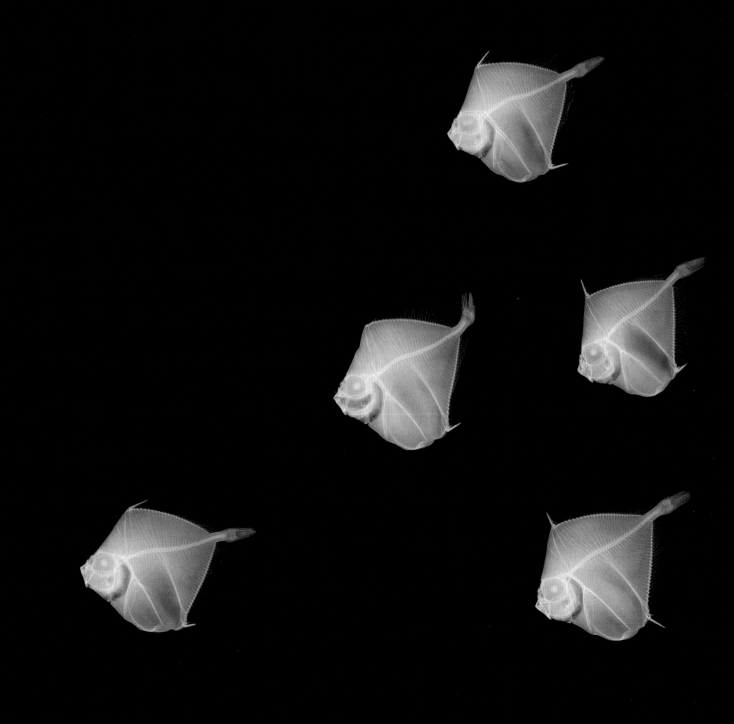

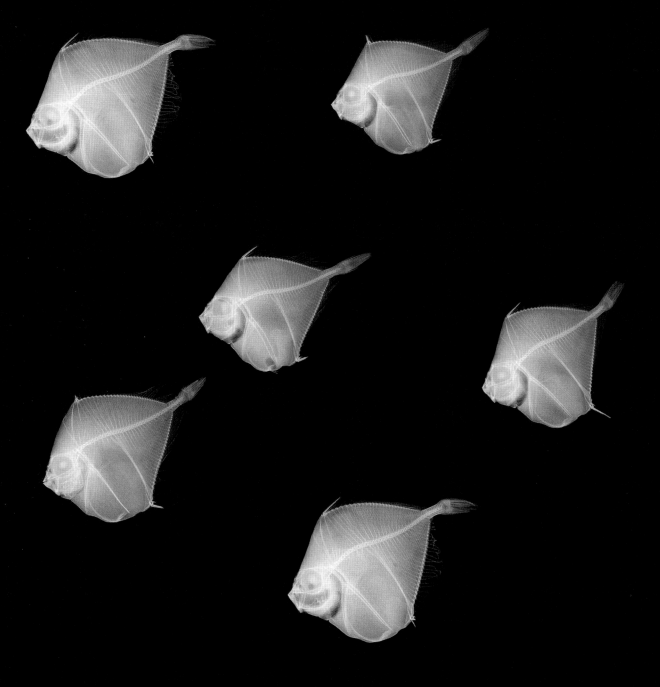

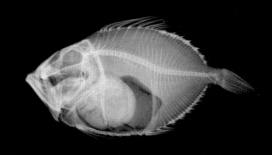
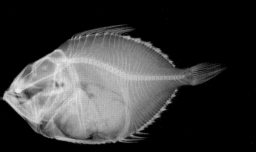

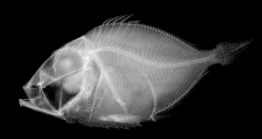
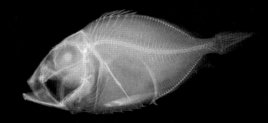

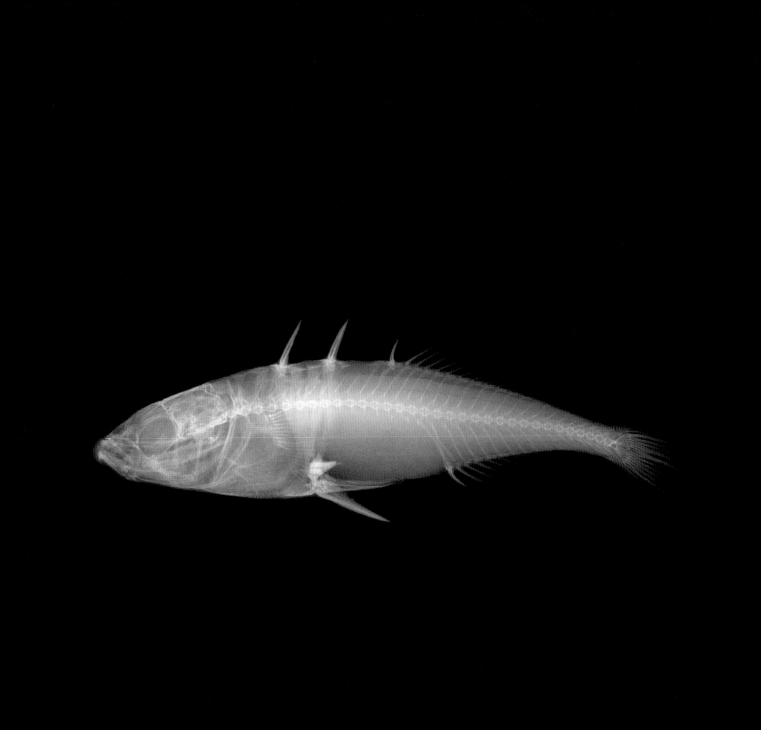

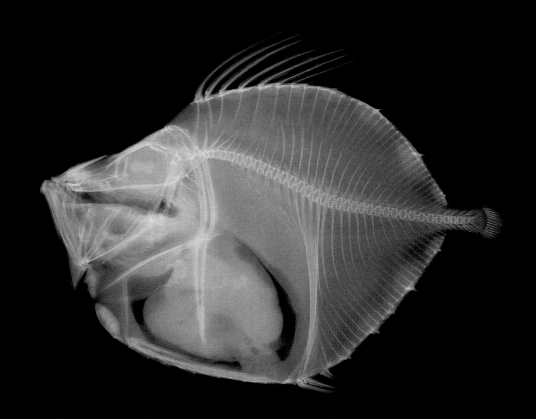

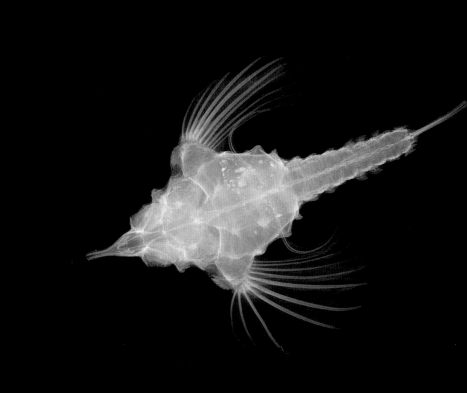

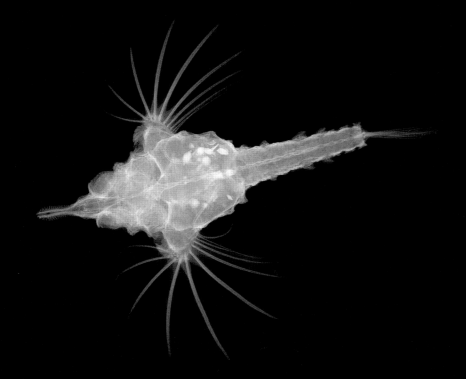

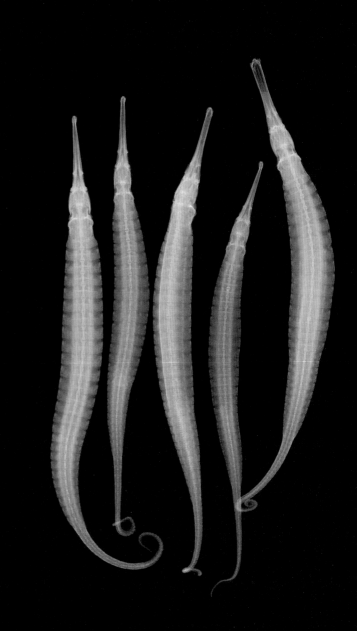

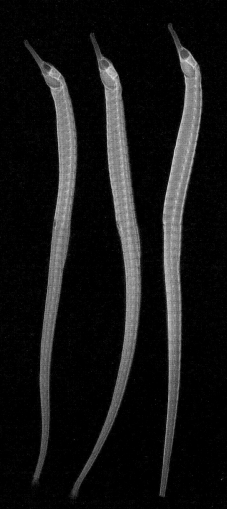

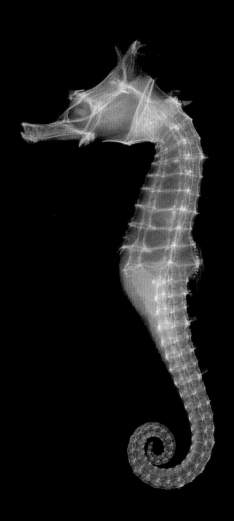

The whole ocean is made up
of little drops.

—AMERICAN PROVERB

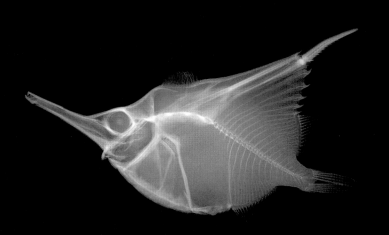

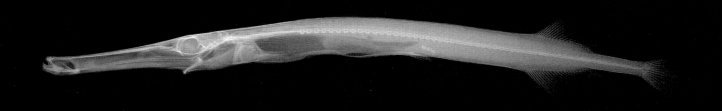

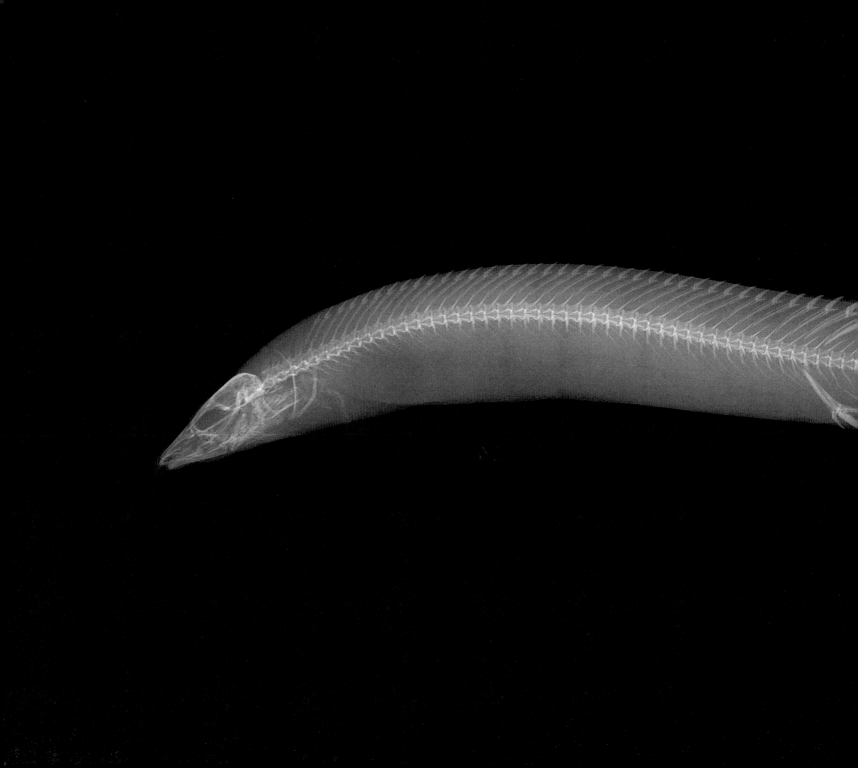

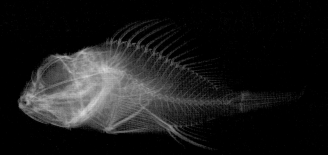

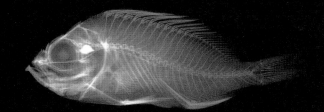
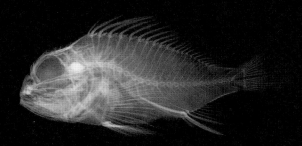

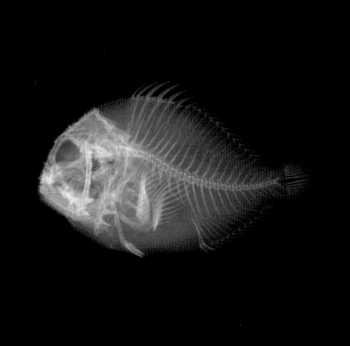

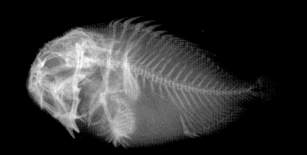
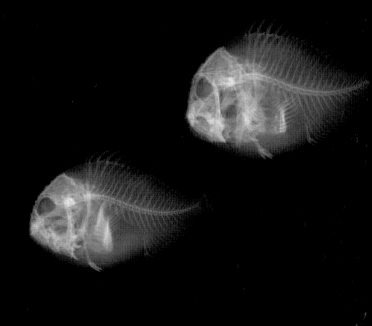

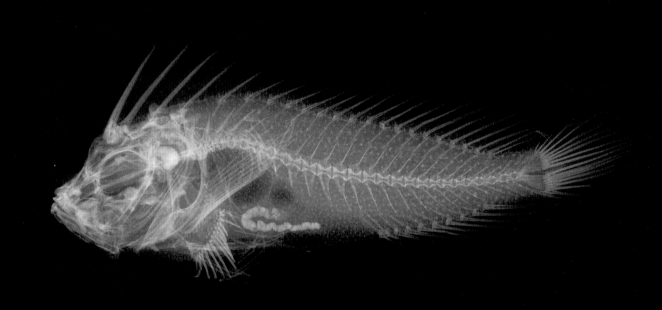

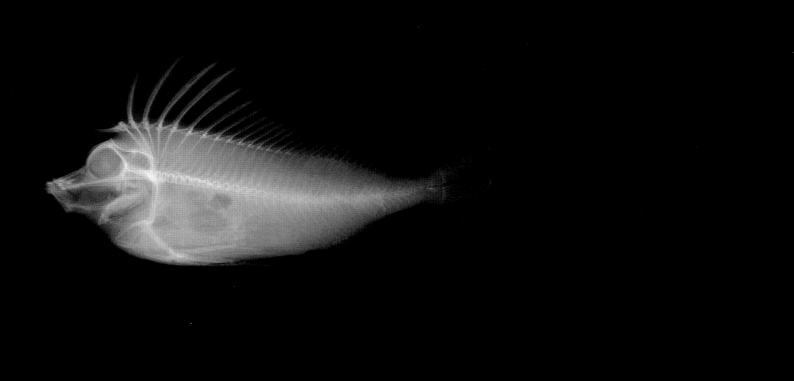
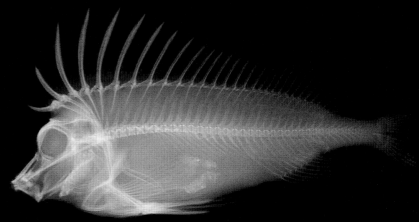

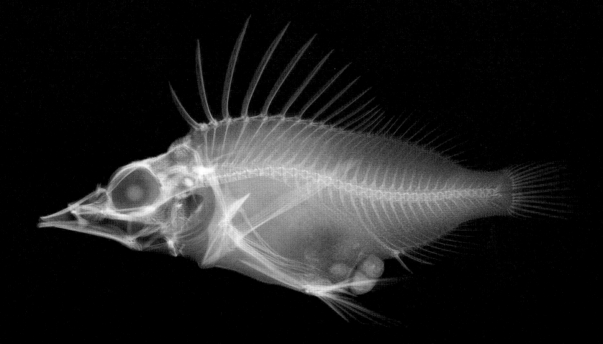

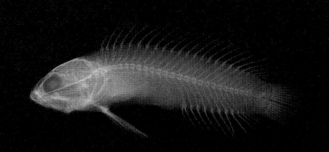

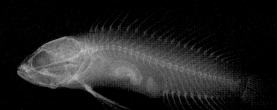
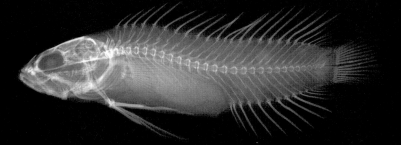

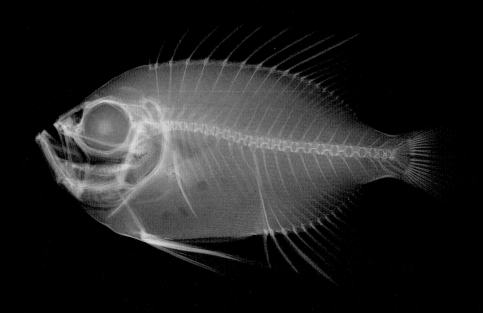

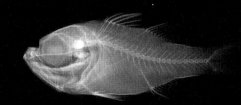

Schools of fish come to those
who wait patiently;
if the big ones don't come,
the little ones will.

—CHINESE PROVERB

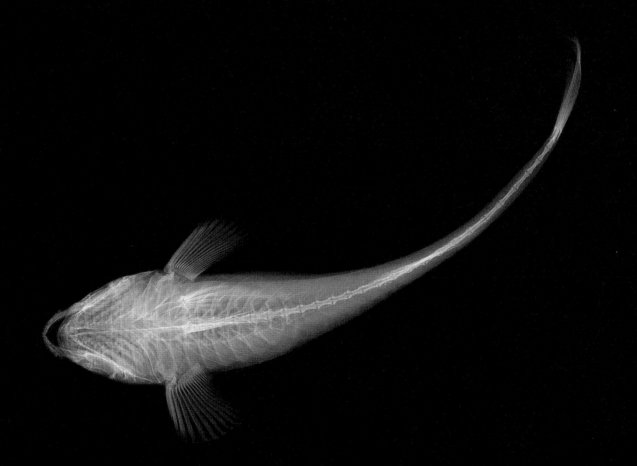

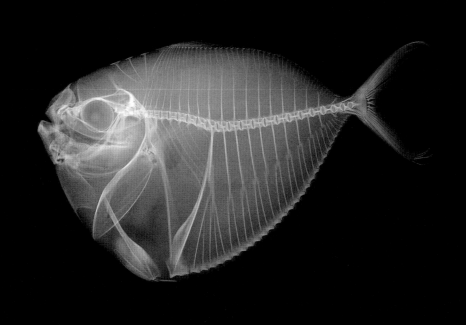

$$\frac{130}{131}$$

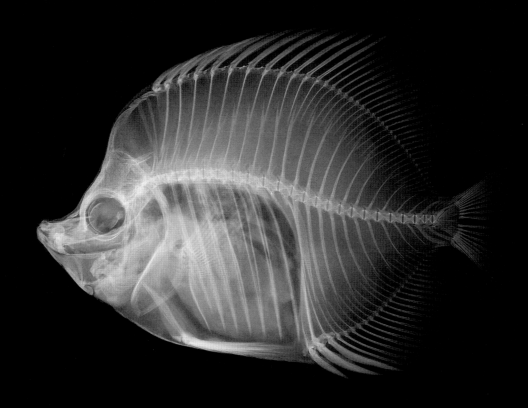

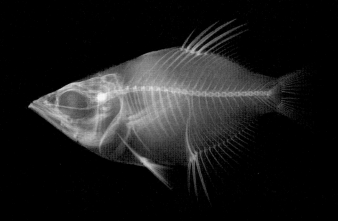

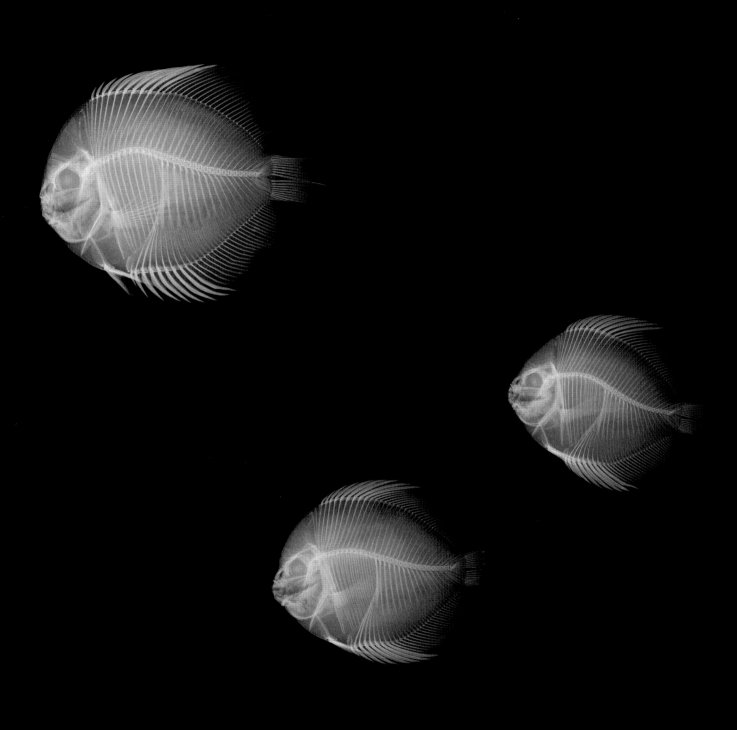

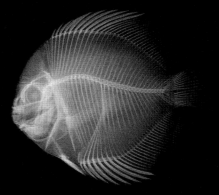
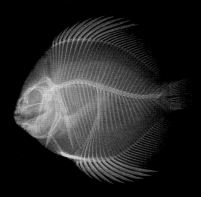

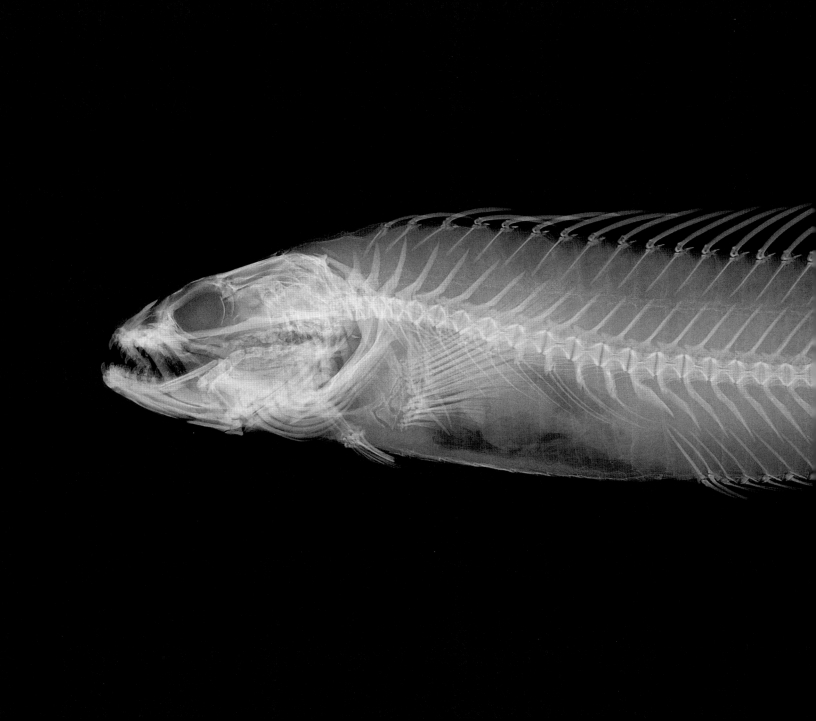

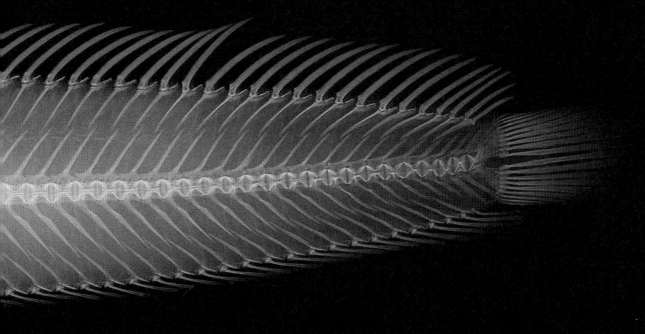

They say the sea is cold,
but the sea contains the hottest
blood of all, and the wildest,
the most urgent.

—D.H. LAWRENCE, 1932

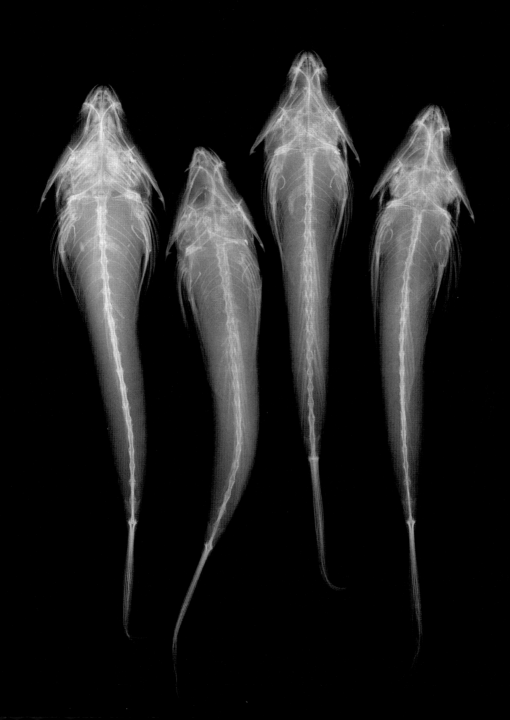

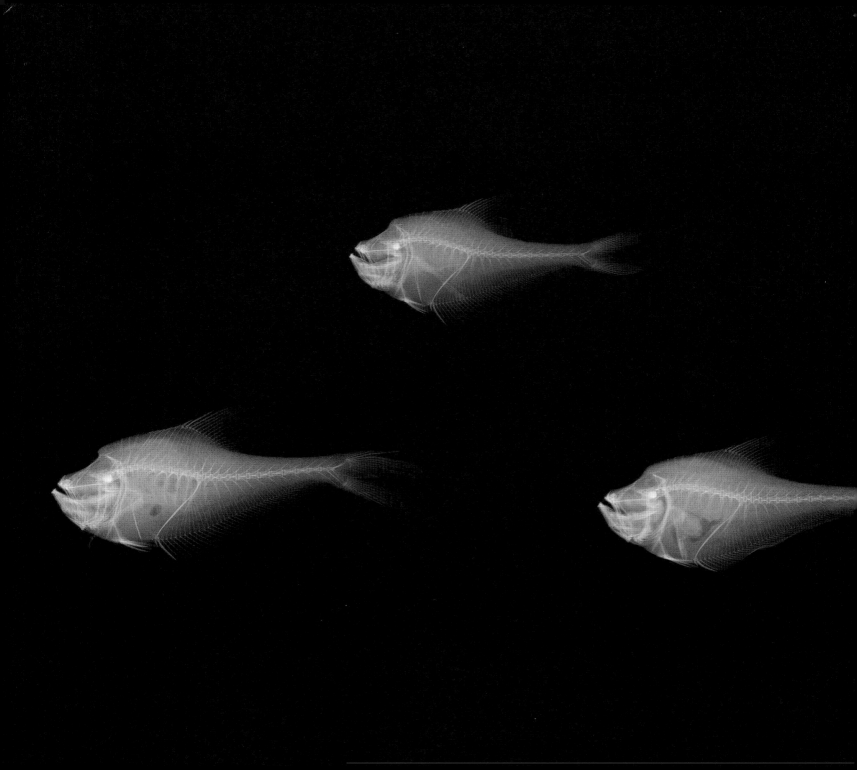

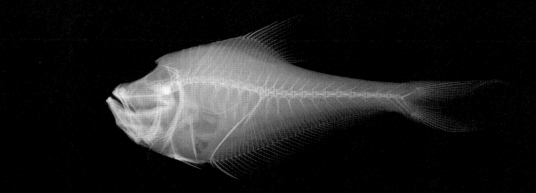
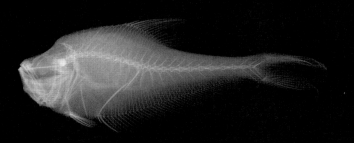

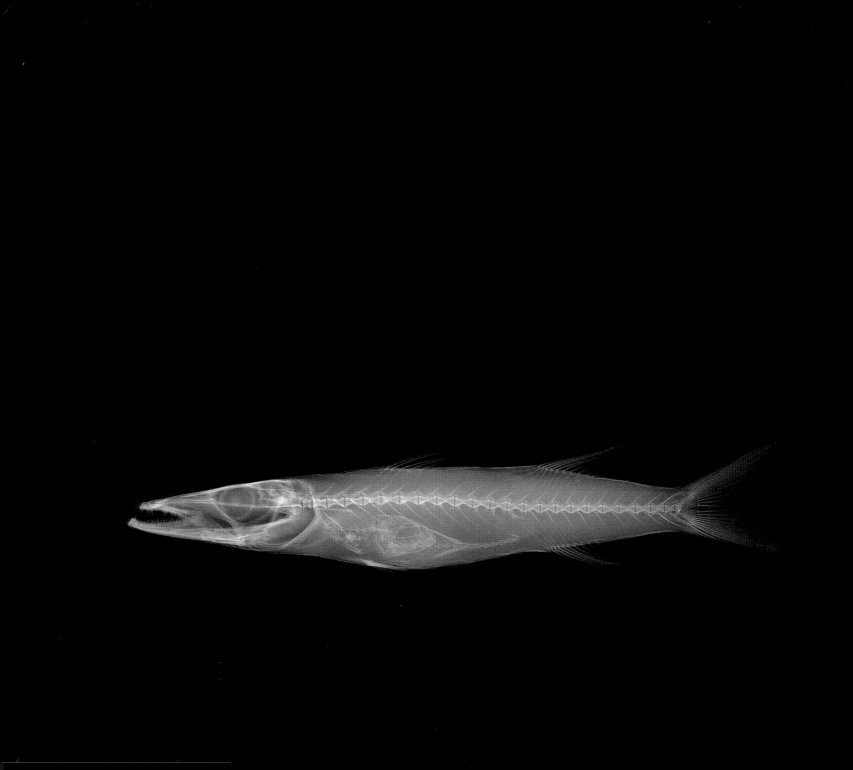

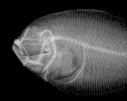

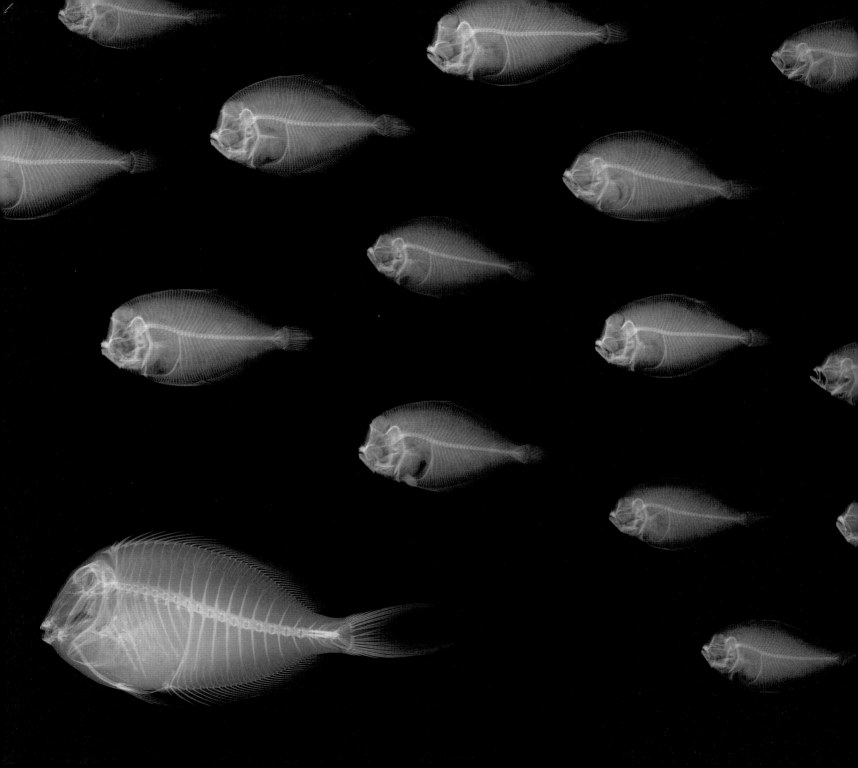

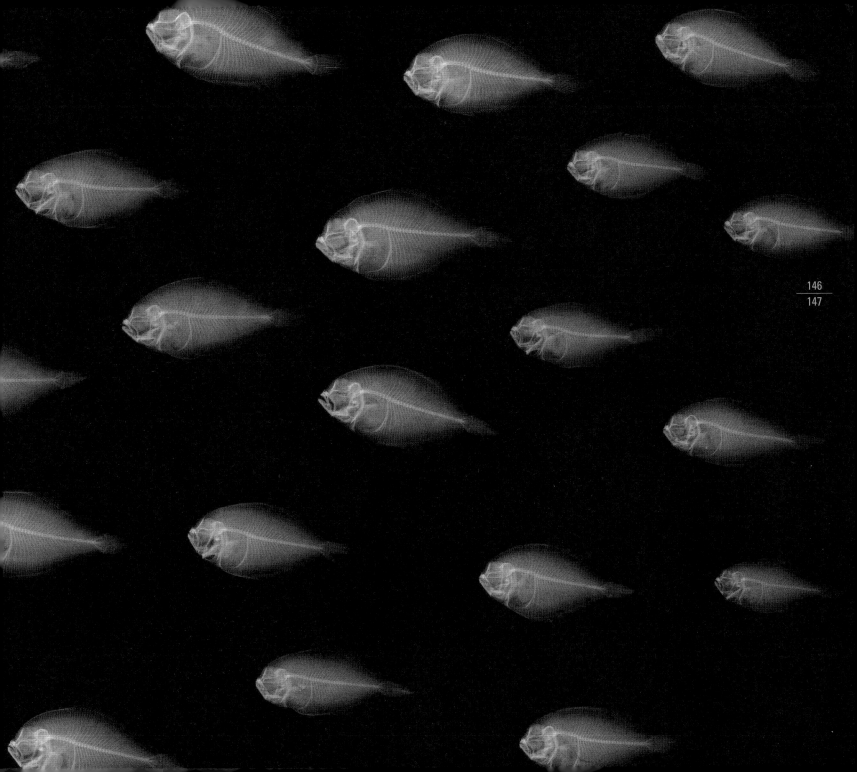

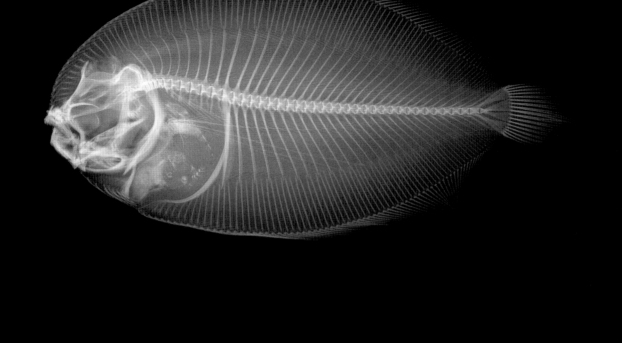

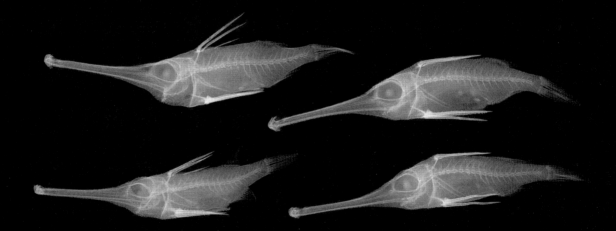

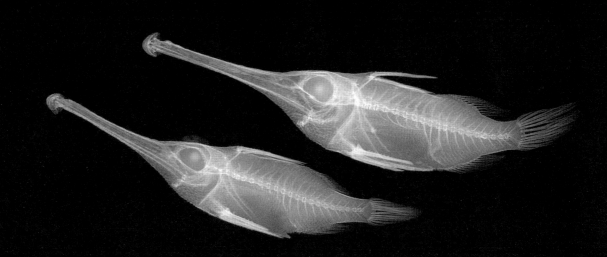

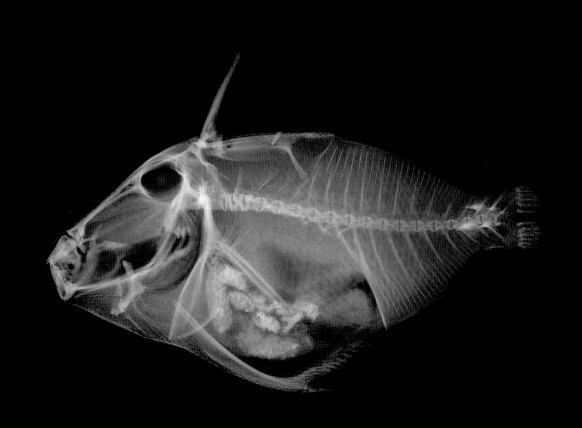

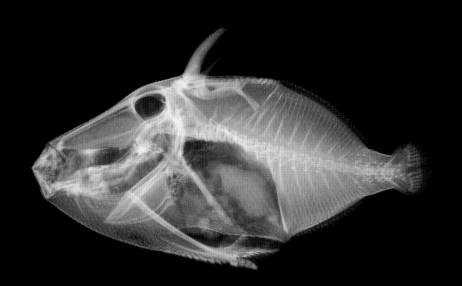

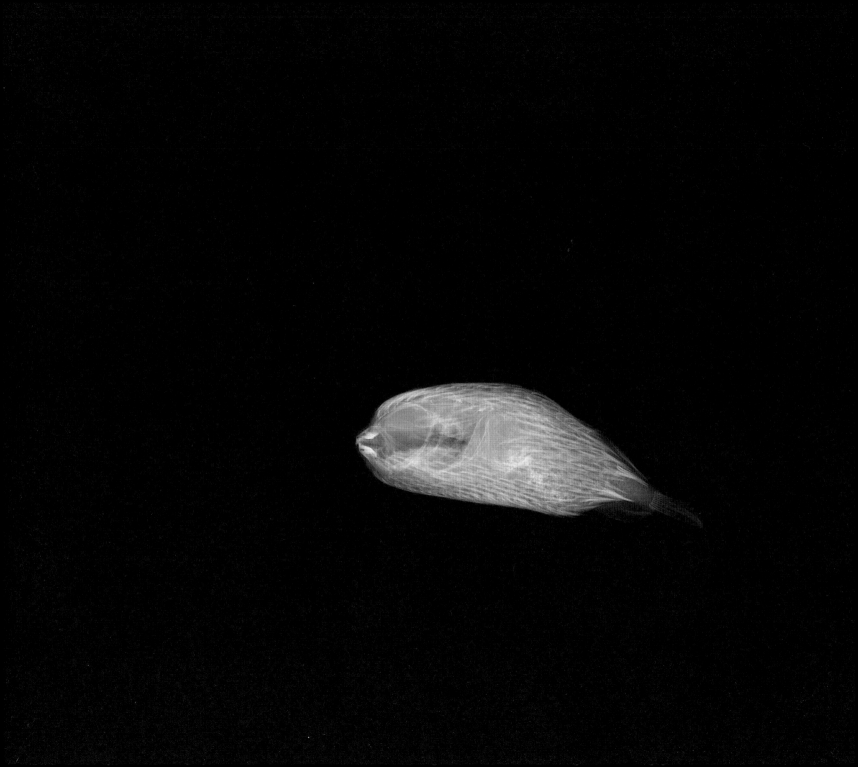

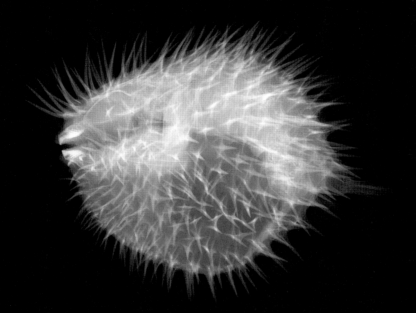

…every art should become
science, and every science
should become art…

—FRIEDRICH VON SCHLEGEL, 1797

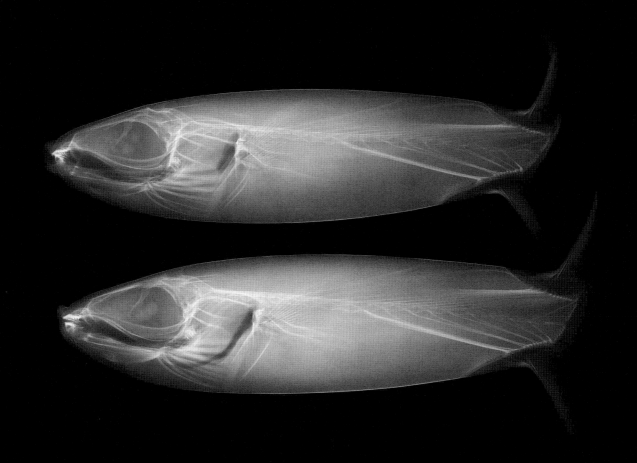

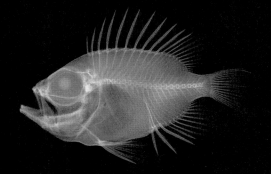

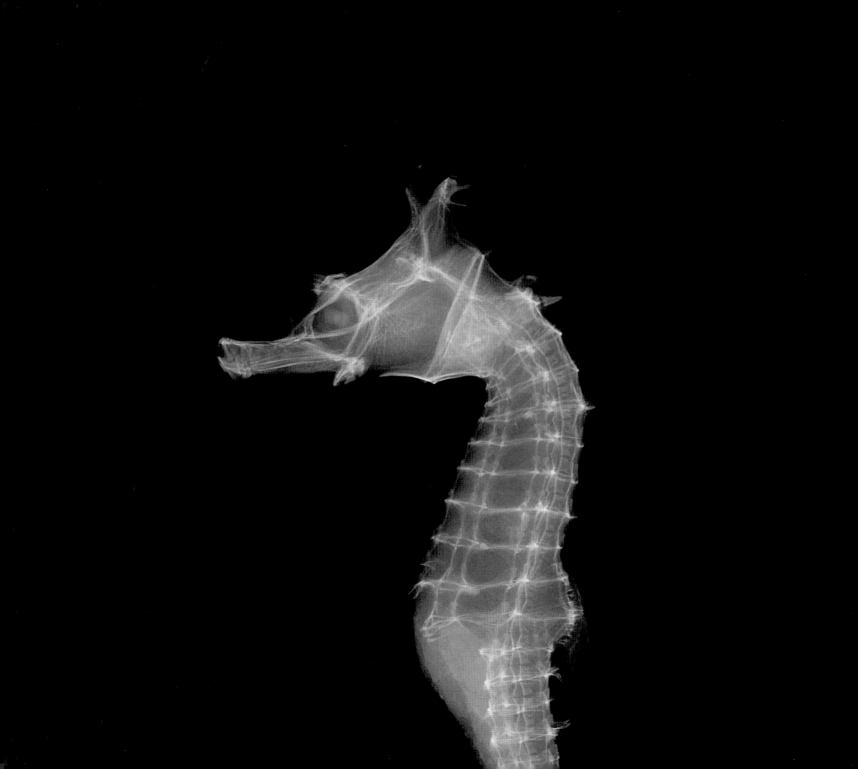

ICHTHYOLOGY AT THE SMITHSONIAN

Dr. Lynne R. Parenti

The Collection and Research
of the Division of Fishes, National
Museum of Natural History,
Smithsonian Institution

The images that grace the pages of this book are of fish specimens largely taken from the vast collections of the Smithsonian Institution's National Museum of Natural History. These and additional radiographs are prepared routinely at the request of individual Smithsonian personnel and other scientists to answer questions posed in their collections-based systematic research on fish. Although naturally artistic, the images are part of the immense body of scientific information held in the National Collection of Fishes.

The Smithsonian's scientific collection of fish began in the mid-nineteenth century with some of the United States' most historically significant biological specimens that were obtained on federally funded expeditions: the United States Exploring Expedition (1838–42), popularly known as the Wilkes Expedition; the U.S. Bureau of Fisheries trawling expeditions conducted by the *Albatross* and other vessels in the late 1800s and early 1900s; and the U.S. Boundary Surveys, such as that between the United States and Mexico in the 1850s. From these auspicious beginnings, the National Collection of Fishes has grown into the largest and

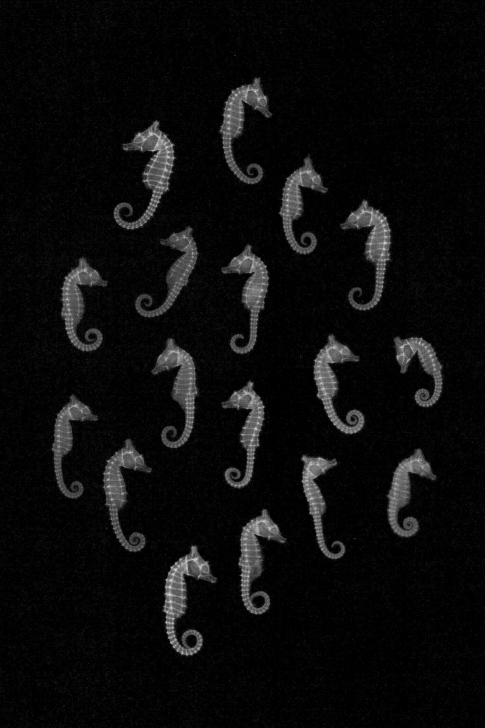

most diverse collection of its kind in the world. Today, an estimated four million individual fish specimens are stored in some 540,000 lots or individual storage containers.

The collection is also the most important of its kind, not simply because of its size, but because of its global coverage and holdings of historically and scientifically important specimens. Some twenty thousand of the twenty-eight thousand known species, or more than 70 percent of all fish species in the world, are represented. Although some species are represented by just one specimen, many more than one specimen of each species—males, females, juveniles, larvae, even eggs—from a variety of habitats are necessary to adequately and completely describe the diversity of a species throughout its geographic range. The number of specimens needed to describe the diversity of fish life on Earth rises quickly from just one specimen for each of the twenty-eight thousand species to many millions.

Fish from the range of global aquatic marine and freshwater habitats, from deep-sea to high-altitude freshwater lakes,

are held in the collection. Notable among the holdings is the world's largest collection of Indo-Pacific marine shore fish, as well as extensive coverage from freshwaters of both North and South America. Among the most valuable specimens are "types," the specimens that an individual scientist had on hand when describing a new species and were selected to represent, or to be "typical" of, that species. The type collection is the largest in the world, with some 18,000 type lots representing 8,100 named species. Many, but not all, of the types are of species described by Smithsonian scientists. Ichthyologists worldwide deposit type specimens in the National Collection of Fishes. They understand that the specimens will be well maintained in perpetuity and made accessible for study by the scientific community.

Such a large, comprehensive global collection on the biodiversity of fish becomes more valuable every year, especially as species go extinct and habitats are altered. The current collection could never be duplicated. It serves as an archive or historical record of fish biodiversity.

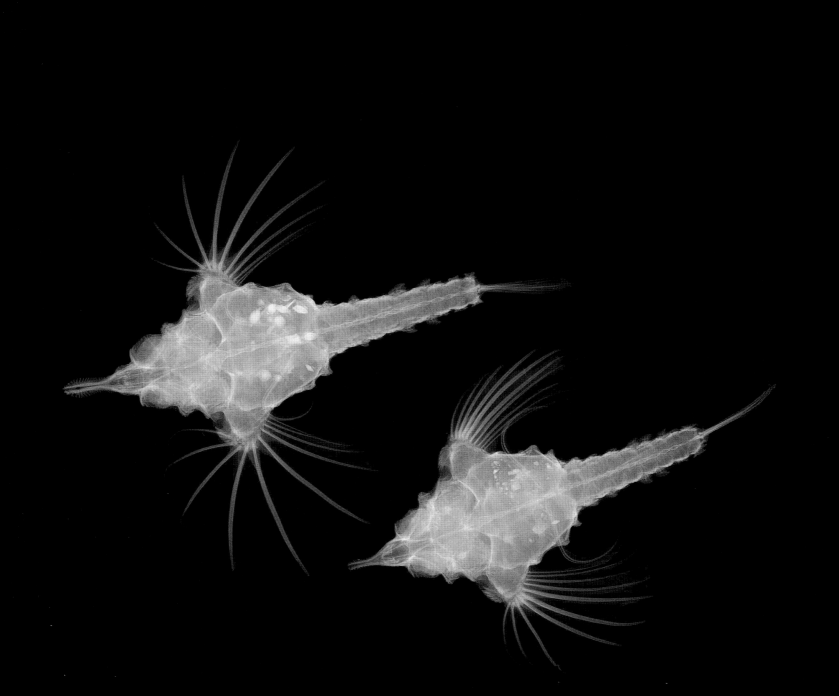

A growing use of the collection is in identifying invasive or exotic species—species that are not native to their current habitat, but that were moved there from elsewhere for food or pest control, as pets, or for other reasons. In 2002, strange fish were found breeding in a pond in Crofton, Maryland. They were readily recognized as snakeheads native to Asia, but what species? Staff in the Division of Fishes worked closely with colleagues in the National Marine Fisheries Service, the U.S. Geological Survey, and the Maryland Department of Natural Resources to identify the species as *Channa argus,* the Northern Snakehead, using the published scientific literature as well as comparing the introduced species with a specimen collected in its native China. No one knows where in the world the next invasive fish species will come from or what kind it will be. Broad, comprehensive fish collections will play an important role in identifying the next exotic species and informing how it should be managed.

Most of the specimens in the fish collection were preserved originally in formalin, an aqueous solution of formaldehyde that became widely used as a preservative (or fixative)

starting in the late 1800s. After one to several days in formalin, depending on the size of the fish, the fixed specimens are rinsed in water and transferred to 75 percent ethyl alcohol for long-term storage. Alcohol is preferred for this purpose over formaldehyde, which decalcifies bone and is also a noxious chemical. Maintenance of the collection by a dedicated, professional staff includes the perpetual task of topping off jars with alcohol, which dissipates readily. The collection is run much like a reference library: specimens are accessioned and catalogued, and may be sent out on loan or studied by resident staff and students or visitors. In one recent year, 150 visitors came to the collection from 14 foreign countries and 18 states, including Hawaii and Alaska.

Research programs of PhD-level staff scientists drive the growth and use of the collection. Several thousand specimens per year are currently being added to the collection from ongoing research projects in the central and western Pacific and the Caribbean. The primary focus of research is fish systematics, from species description to higher-level phylogenetic analysis and biogeography.

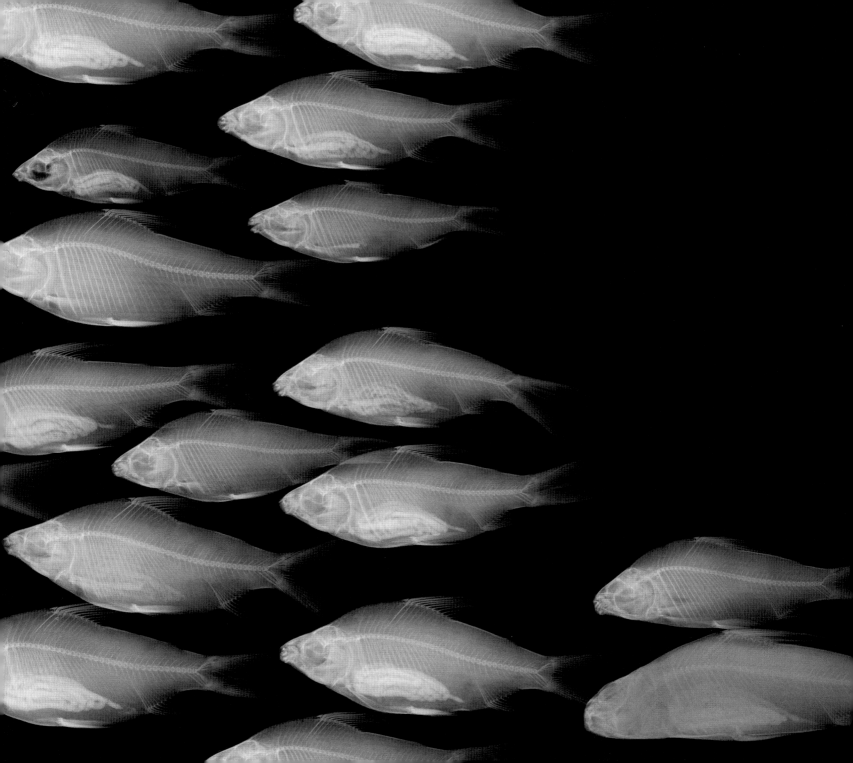

The collection is physically laid out in an evolutionary or phylogenetic sequence, from the most primitive, jawless hagfishes and lampreys to the most derived spiny-finned fishes, such as perch and bass. This is the sequence mirrored in the layout of the images in this book.

This phylogenetic framework is built on two general aspects of fish that have been studied for over three centuries: external anatomy, including color patterns, and osteology—the bony skeleton. Variation in the soft anatomy—muscles, nerves, blood vessels, and internal organs—and in molecular sequence data from DNA has been studied to a much lesser extent, although use of data from these systems is growing. The bony skeleton is not likely to be replaced by these or other systems as one of the principal sources of information on fish systematics, as it is the most durable part of the body. And fossil fishes are known virtually solely by their skeletons.

Osteology of fish began with the study of dissected specimens or dry skeletons. The National Collection of Fishes has nearly five thousand dry skeletons that were prepared from freshly caught or frozen specimens. New dry skeletons are prepared mainly of large specimens, over a foot or more in length, such as paddlefish or tuna. Osteology of smaller specimens, which make up the majority of those studied, is examined using specially prepared skeletons stored in glycerin ("wet" skeletons), of which the collection has another five thousand specimens, and using radiographs or X-rays.

Radiographs allow the study of the skeleton of a fish without dissecting or in any other way altering the specimen. They are relatively quick and easy to prepare. Sandra Raredon has mastered the technique on a digital radiography system. Radiographs may be prepared of any specimen, often unique or rare specimens, or, alternatively, large samples in which a researcher wishes to compare features among a group of individuals. The results of such comparisons are published in the scientific literature on fish systematics, and the images become part of the archives of the National Collection of Fishes.

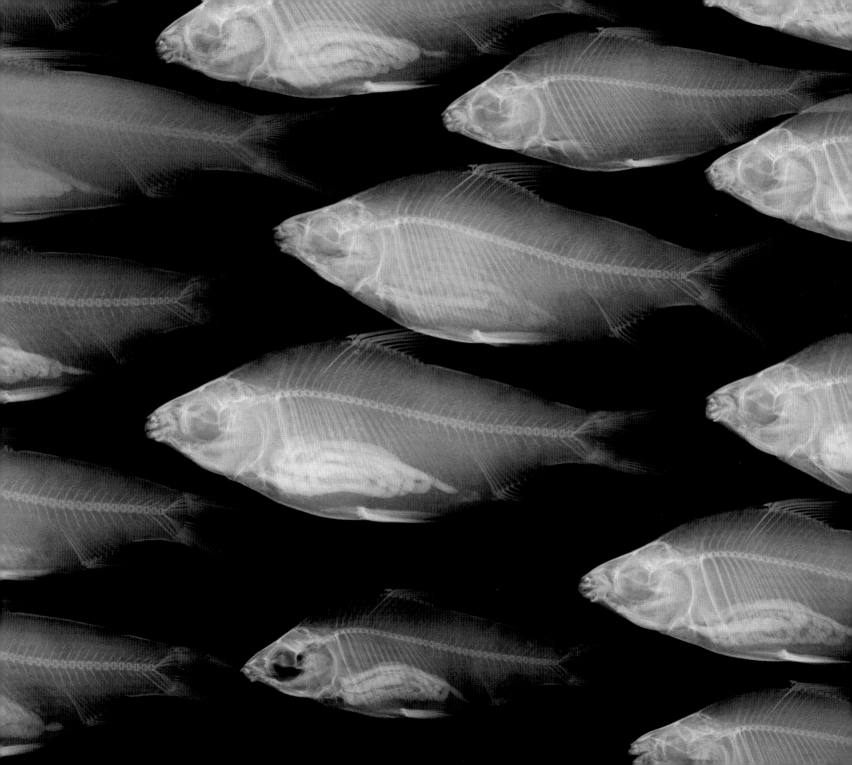

The radiographic images in this book largely follow scientific, not artistic, conventions: there is one specimen per frame, and it is facing left. Specimens are sometimes grouped together to save time of radiograph preparation or to facilitate comparison. Characteristics of the skeleton can be seen readily: number of vertebrae, number of fin spines, configuration of the bones that support the caudal or tail skeleton, and relative size and shape of the jaw bones. Some fish have sharp, thickened fin spines; others have spines that are thin and obviously flexible. Some fish have teeth in their jaws; others none at all. Enjoy these images for their natural, artistic beauty, and also for the role they play in the scientific understanding of the diversity of fishes. ■

VISUAL DIRECTORY

Page 6

Acanthoplesiops hiatti

Plesiopid

LOCATION: Pacific Ocean

ORDER: Perciformes

FAMILY: Plesiopidae

USMN: 140757

COLLECTED: 1946

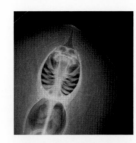

Page 14

Himantura signifer

Stingray

LOCATION: Pacific Ocean

ORDER: Rajiformes

FAMILY: Dasyatidae

USMN: 229492

COLLECTED: 1976

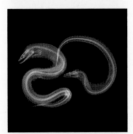

Page 8

Enchelynassa canina

Moray eel

LOCATION: American Samoa

ORDER: Anguilliformes

FAMILY: Muraenidae

USMN: 116076

COLLECTED: 1939

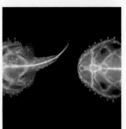

Page 16

Halieutichthys reticulatus

Batfish

LOCATION: Florida

ORDER: Lophiiformes

FAMILY: Ogcocephalidae

USMN: 134197

COLLECTED: 1885

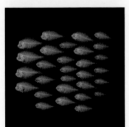

Page 10

Engyprosopon xenandrus

Lefteye flounder

LOCATION: Hawaii

ORDER: Pleuronectiformes

FAMILY: Bothidae

USMN: 51687

COLLECTED: 1902

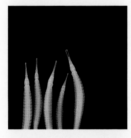

Page 18

Syngnathoides biaculeatus

Pipefish

LOCATION: Philippines

ORDER: Syngnathiformes

FAMILY: Syngnathidae

USMN: 112904

COLLECTED: 1929

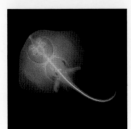

Page 12

Raja montereyensis

Skate

LOCATION: Pacific Ocean

ORDER: Rajiformes

FAMILY: Rajiidae

USMN: 75806

COLLECTED: 1904

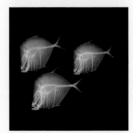

Page 20

Selene vomer

Jack

LOCATION: Florida

ORDER: Perciformes

FAMILY: Carangidae

USMN: 184259

COLLECTED: 1958

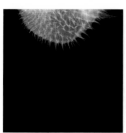

Page 22

Diodon holocanthus

Porcupine fish

LOCATION: Philippines

ORDER: Tetraodontiformes

FAMILY: Diodontidae

USMN: 228556

COLLECTED: 1978

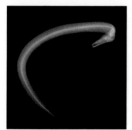

Page 24

Enchelycore bayeri

Moray eel

LOCATION: Pacific Ocean

ORDER: Anguilliformes

FAMILY: Muraenidae

USMN: 371009

COLLECTED: 2000

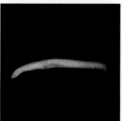

Page 29

Eptatretus minor

Hagfish

LOCATION: Atlantic Ocean

ORDER: Myxiniformes

FAMILY: Myxinidae

USMN: 164119

COLLECTED: 1954

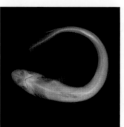

Page 31

Mustelus manazo

Houndshark

LOCATION: Indian Ocean

ORDER: Carcharhiniformes

FAMILY: Triakidae

USMN: 196449

COLLECTED: Unknown

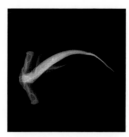

Page 33

Sphyrna blochii

Hammerhead shark

LOCATION: Indian Ocean

ORDER: Carcharhiniformes

FAMILY: Sphyrnidae

USMN: 222045

COLLECTED: 1970

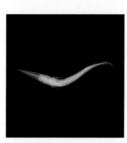

Pages 34–35

Pristis pectinata

Sawfish

LOCATION: Atlantic Ocean

ORDER: Pristiformes

FAMILY: Pristidae

USMN: 42374

COLLECTED: Unknown

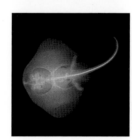

Page 36

Raja montereyensis

Skate

LOCATION: Pacific Ocean

ORDER: Rajiformes

FAMILY: Rajiidae

USMN: 75806

COLLECTED: 1904

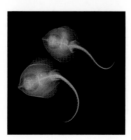

Page 37

Raja bigelowi

Skate

LOCATION: Atlantic Ocean

ORDER: Rajiformes

FAMILY: Rajiidae

USMN: 218273

COLLECTED: 1969

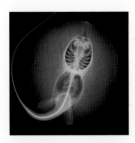

Page 39

Himantura signifer

Stingray

LOCATION: Pacific Ocean

ORDER: Rajiformes

FAMILY: Dasyatidae

USMN: 229492

COLLECTED: 1976

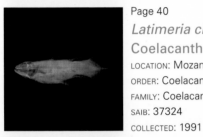

Page 40

Latimeria chalumnae

Coelacanth

LOCATION: Mozambique

ORDER: Coelacanthidae

FAMILY: Coelacanthiformes

SAIB: 37324

COLLECTED: 1991

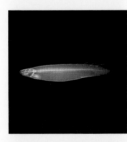

Page 42

Polypterus polli

Bichir

LOCATION: Unknown

ORDER: Polypteriformes

FAMILY: Polypteridae

USMN: 374495

COLLECTED: Unknown

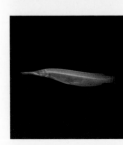

Page 43

Atractosteus tropicus

Gar

LOCATION: Costa Rica

ORDER: Lepisosteiformes

FAMILY: Lepisosteidae

USMN: 6806

COLLECTED: Unknown

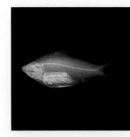

Pages 44–45

Prochilodus magdalenae

Curimatid

LOCATION: Colombia

ORDER: Characiformes

FAMILY: Prochilodontidae

USMN: 76962

COLLECTED: 1916

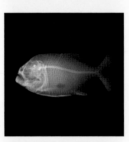

Page 46

Pygocentrus caribe

Characin

LOCATION: Venezuela

ORDER: Characiformes

FAMILY: Characidae

USMN: 257338

COLLECTED: 1925

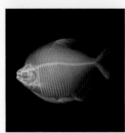

Page 46

Mylossoma paraguayensis

Piranha

LOCATION: Paraguay

ORDER: Characiformes

FAMILY: Characidae

USMN: 5888

COLLECTED: Unknown

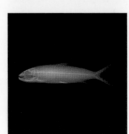

Pages 46–47

Hydrocynus forskahlii

Characin

LOCATION: Africa

ORDER: Characiformes

FAMILY: Alestiidae

USMN: 48519

COLLECTED: 1897

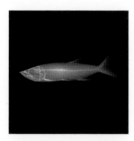

Page 47

Acestrorhynchus falcatus

Characin

LOCATION: Peru

ORDER: Characiformes

FAMILY: Acestrorhynchidae

USMN: 319607

COLLECTED: 1991

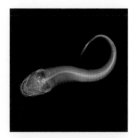

Page 54

Clarias laeviceps

Air-breathing catfish

LOCATION: Africa

ORDER: Siluriformes

FAMILY: Clariidae

USMN: 4099

COLLECTED: 1850s

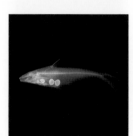

Page 49

Helicophagus leptorhynchus

Pangasid catfish

LOCATION: Thailand

ORDER: Siluriformes

FAMILY: Pangasiidae

USMN: 288676

COLLECTED: 1971

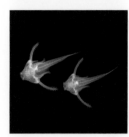

Page 56

Physopyxis lyra

Thorny catfish

LOCATION: Peru

ORDER: Siluriformes

FAMILY: Doradidae

USMN: 284583

COLLECTED: 1986

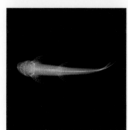

Page 50

Doumea thysi

Loach catfish

LOCATION: Africa

ORDER: Siluriformes

FAMILY: Amphiliidae

USMN: 303603

COLLECTED: 1988

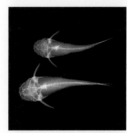

Page 59

Microglanis cottoides

Long-whiskered catfish

LOCATION: Brazil

ORDER: Siluriformes

FAMILY: Pseudopimelodidae

USMN: 285838

COLLECTED: 1985

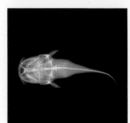

Page 53

Chaca bankanensis

Squarehead

LOCATION: Indonesia

ORDER: Siluriformes

FAMILY: Chacidae

USMN: 230310

COLLECTED: 1976

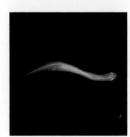

Page 60

Vandellia

Parasitic catfish

LOCATION: Peru

ORDER: Siluriformes

FAMILY: Trichomycteridae

USMN: 319659

COLLECTED: 1991

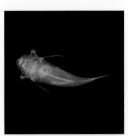

Page 62

Ancistrus triradiatus

Suckermouth armored catfish

LOCATION: Venezuela

ORDER: Siluriformes

FAMILY: Loricariidae

USMN: 121064

COLLECTED: 1942

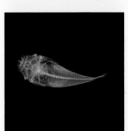

Page 62

Corymbophanes venezuelae

Suckermouth armored catfish

LOCATION: Venezuela

ORDER: Siluriformes

FAMILY: Loricariidae

USMN: 120752

COLLECTED: 1942

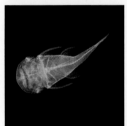

Page 63

Pseudancistrus torbesensis

Suckermouth armored catfish

LOCATION: Venezuela

ORDER: Siluriformes

FAMILY: Loricariidae

USMN: 121001

COLLECTED: 1942

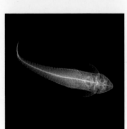

Page 65

Crossoloricaria venezuelae

Armored catfish

LOCATION: Colombia

ORDER: Siluriformes

FAMILY: Loricariidae

USMN: 217428

COLLECTED: 1968

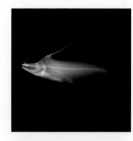

Page 67

Tetranematichthys

Woodcat catfish

LOCATION: Peru

ORDER: Siluriformes

FAMILY: Auchenipteridae

ANSP: 128688

COLLECTED: Unknown

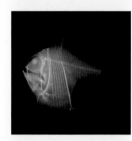

Pages 68, 69

Sternoptychus

Marine hatchetfish

LOCATION: Pacific Ocean

ORDER: Stomiiformes

FAMILY: Sternoptychidae

USMN: Uncatalogued

COLLECTED: Unknown

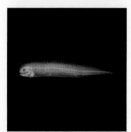

Pages 70–71

Lophotus lacepede

Crestfish

LOCATION: Florida

ORDER: Lampridiformes

FAMILY: Radiicephalidae

USMN: 151118

COLLECTED: 1950

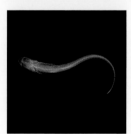

Pages 72–73

Ipnops agassizii

Greeneye

LOCATION: Galapagos Islands

ORDER: Aulopiformes

FAMILY: Ipnopidae

USMN: 153593

COLLECTED: 1891

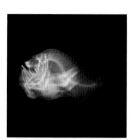

Page 74

Antennarius commerson

Frogfish

LOCATION: Hawaii

ORDER: Lophiiformes

FAMILY: Antennariidae

USMN: 167508

COLLECTED: 1955

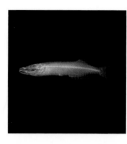

Page 78

Xenopoecilus poptae

Ricefish

LOCATION: Indonesia

ORDER: Beloniformes

FAMILY: Adrianichthyidae

CMK: 5775

COLLECTED: 1983

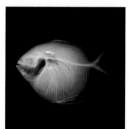

Page 75

Lampris guttatus

Opah

LOCATION: Baja California

ORDER: Lampridiformes

FAMILY: Lamprididae

SIO: 82-70

COLLECTED: 1982

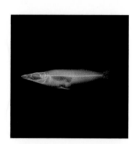

Page 78

Adrianichthys roseni

Adrianichthyid

LOCATION: Sulawesi

ORDER: Beloniformes

FAMILY: Adrianichthyidae

USMN: 322424

COLLECTED: 1978

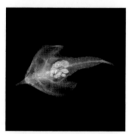

Page 76

Ogcocephalus corniger

Batfish

LOCATION: Florida

ORDER: Lophiiformes

FAMILY: Ogcocephalidae

USMN: 188808

COLLECTED: 1952

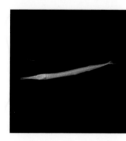

Page 79

Tylosurus crocodilus

Needlefish

LOCATION: India

ORDER: Beloniformes

FAMILY: Belonidae

USMN: 223782

COLLECTED: 1980

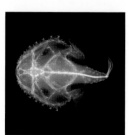

Page 77

Halieutichthys reticulatus

Batfish

LOCATION: Florida

ORDER: Lophiiformes

FAMILY: Ogcocephalidae

USMN: 134197

COLLECTED: 1885

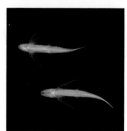

Page 81

Cypselurus heterurus

Flying fish

LOCATION: Atlantic Ocean

ORDER: Beloniformes

FAMILY: Exocoetidae

USMN: 197836

COLLECTED: 1960

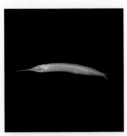

Page 82

Hyporhamphus unifasciatus

Halfbeak

LOCATION: Bermuda

ORDER: Beloniformes

FAMILY: Hemiramphidae

USMN: 330030

COLLECTED: 1993

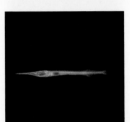

Page 83

Xenentodon cf. canila

Halfbeak

LOCATION: Southeast Asia

ORDER: Beloniformes

FAMILY: Hemiramphidae

LACM: 56002

COLLECTED: 2002

Pages 84, 85

Melamphaes pumilus

Bigscale fish

LOCATION: Bermuda

ORDER: Stephanoberyciformes

FAMILY: Melamphaidae

USMN: 249592

COLLECTED: 1968

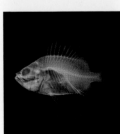

Page 87

Corniger spinosus

Squirrelfish

LOCATION: Alabama

ORDER: Beryciformes

FAMILY: Holocentridae

USMN: 358599

COLLECTED: 1999

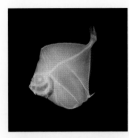

Pages 88, 89

Xenolepidichthys dalgleishi

Spotted Tinselfish

LOCATION: Nicaragua

ORDER: Zeiformes

FAMILY: Grammicolepididae

USMN: 322673

COLLECTED: 1962

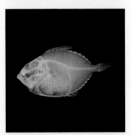

Page 91

Zeus faber

Dory

LOCATION: Atlantic Ocean

ORDER: Zeiformes

FAMILY: Zeidae

USMN: 341533

COLLECTED: 1963

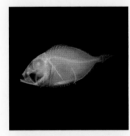

Page 91

Stethopristes

Dory

LOCATION: Pacific Ocean

ORDER: Zeiformes

FAMILY: Parazenidae

USMN: 334054

COLLECTED: 1987

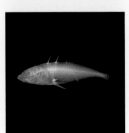

Page 92

Gasterosteus aculeatus

Stickleback

LOCATION: California

ORDER: Gasterosteiformes

FAMILY: Gasterosteidae

USMN: 369800

COLLECTED: 2001

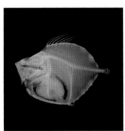

Page 95

Zenopsis conchifera

Dory

LOCATION: Atlantic Ocean

ORDER: Zeiformes

FAMILY: Zeidae

USMN: 302362

COLLECTED: 1988

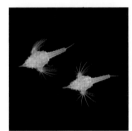

Pages 96, 97

Pegasus draconis

Seamoth

LOCATION: Philippines

ORDER: Gasterosteiformes

FAMILY: Pegasidae

USMN: USNM 137201

COLLECTED: 1908

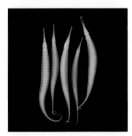

Page 98

Syngnathoides biaculeatus

Pipefish

LOCATION: Philippines

ORDER: Syngnathiformes

FAMILY: Syngnathidae

USMN: 112904

COLLECTED: 1929

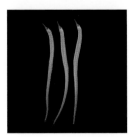

Page 99

Corythoichthys haematopterus

Pipefish

LOCATION: Solomon Islands

ORDER: Syngnathiformes

FAMILY: Syngnathidae

USMN: 214991

COLLECTED: 1974

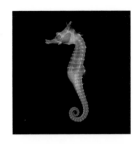

Page 101

Hippocampus sindonis

Seahorse

LOCATION: Japan

ORDER: Syngnathiformes

FAMILY: Syngnathidae

USMN: 49730

COLLECTED: 1907

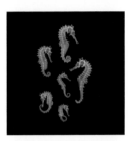

Page 103

Hippocampus erectus

Seahorse

LOCATION: Florida

ORDER: Syngnathiformes

FAMILY: Syngnathidae

USMN: 116910

COLLECTED: Unknown

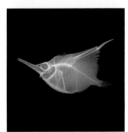

Page 104

Notopogon schoteli

Snipefish

LOCATION: Atlantic Ocean

ORDER: Syngnathiformes

FAMILY: Centriscidae

USMN: 85511

COLLECTED: Unknown

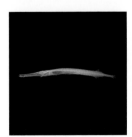

Page 105

Aulostomus maculatus

Trumpetfish

LOCATION: Alabama

ORDER: Syngnathiformes

FAMILY: Aulostomidae

USMN: 358598

COLLECTED: 1999

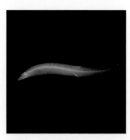

Pages 106–107
Mastacembelus armatus
Spiny eel
LOCATION: Myanmar
ORDER: Synbranchiformes
FAMILY: Mastacembelidae
USMN: 344665
COLLECTED: 1996

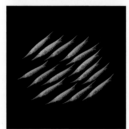

Page 109
Centriscus
Shrimpfish
LOCATION: Unknown
ORDER: Gasterosteiformes
FAMILY: Centriscidae
USMN: Uncatalogued
COLLECTED: Unknown

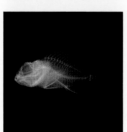

Page 110
Scorpaenopsis altirostris
Scorpionfish
LOCATION: Hawaii
ORDER: Scorpaeniformes
FAMILY: Scorpaenidae
USMN: 51636
COLLECTED: 1902

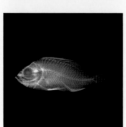

Page 111
Sebastodes scythropus
Scorpionfish
LOCATION: Japan
ORDER: Scorpaeniformes
FAMILY: Sebastidae
USMN: 49406
COLLECTED: Unknown

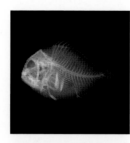

Pages 112, 113
Caracanthus madagascariensis
Orbicular velvetfish
LOCATION: Indian Ocean
ORDER: Scorpaeniformes
FAMILY: Scorpaenidae
USMN: 224423
COLLECTED: 1967

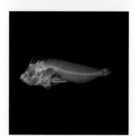

Page 114
Cocotropus larvatus
Velvetfish
LOCATION: Indonesia
ORDER: Scorpaeniformes
FAMILY: Aploactinidae
USMN: 280267
COLLECTED: 1974

Page 116
Congiopodus leucopaecilus
Pigfish, Racehorse
LOCATION: New Zealand
ORDER: Scorpaeniformes
FAMILY: Congiopodidae
USMN: 242018
COLLECTED: Unknown

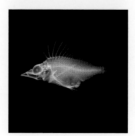

Page 117
Alertichthys blacki
Pigfish, Racehorse
LOCATION: New Zealand
ORDER: Scorpaeniformes
FAMILY: Congiopodidae
USMN: 318386
COLLECTED: 1990

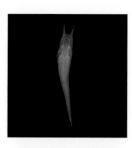

Pages 118, 119
Peristedion weberi
Armored Searobin
LOCATION: Mozambique
ORDER: Scorpaeniformes
FAMILY: Triglidae
USMN: 307856
COLLECTED: 1988

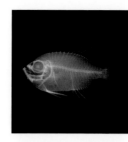

Page 122
Cookeolus japonicus
Bigeye
LOCATION: Unknown
ORDER: Perciformes
FAMILY: Priacanthidae
USMN: Uncatalogued
COLLECTED: Unknown

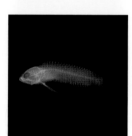

Pages 120, 121
Acanthoplesiops hiatti
Plesiopid
LOCATION: Pacific Ocean
ORDER: Perciformes
FAMILY: Plesiopidae
USMN: 140757
COLLECTED: 1946

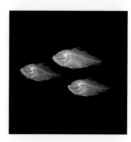

Page 123
Siphamia
Cardinalfish
LOCATION: Tonga
ORDER: Perciformes
FAMILY: Apogonidae
USMN: 341602
COLLECTED: 1993

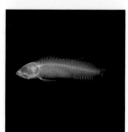

Page 121
Acanthoplesiops hiatti
Plesiopid
LOCATION: Pacific Ocean
ORDER: Perciformes
FAMILY: Plesiopidae
USMN: 257871
COLLECTED: 1968

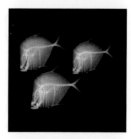

Page 125
Selene vomer
Jack
LOCATION: Florida
ORDER: Perciformes
FAMILY: Carangidae
USMN: 184259
COLLECTED: 1958

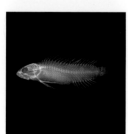

Page 121
Acanthoplesiops hiatti
Plesiopid
LOCATION: Pacific Ocean
ORDER: Perciformes
FAMILY: Plesiopidae
USMN: 140754
COLLECTED: 1946

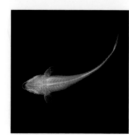

Page 127
Remora osteochir
Sharksucker
LOCATION: Virginia
ORDER: Perciformes
FAMILY: Echeneidae
USMN: 181894
COLLECTED: 1957

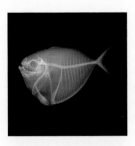

Page 128
Mene maculata
Moonfish
LOCATION: Philippines
ORDER: Perciformes
FAMILY: Menidae
USMN: 340531
COLLECTED: 1995

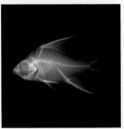

Page 129
Eugerres awlae
Mojarra
LOCATION: Venezuela
ORDER: Perciformes
FAMILY: Gerreidae
USMN: 121721
COLLECTED: 1942

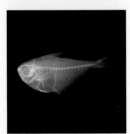

Page 130
Pempheris schwenkii
Sweeper
LOCATION: Fiji
ORDER: Perciformes
FAMILY: Pempheridae
USMN: 287862
COLLECTED: 1986

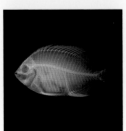

Page 130
Chaetodon plebeius
Butterfly fish
LOCATION: Vanuatu
ORDER: Perciformes
FAMILY: Chaetodontidae
USMN: 356607
COLLECTED: 1996

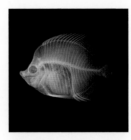

Page 133
Chaetodon lineolatus
Butterfly fish
LOCATION: Mauritius
ORDER: Perciformes
FAMILY: Chaetodontidae
USMN: 279935
COLLECTED: 1976

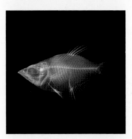

Page 134
Toxotes jaculator
Archerfish
LOCATION: Borneo
ORDER: Perciformes
FAMILY: Toxotidae
USMN: 366714
COLLECTED: 1997

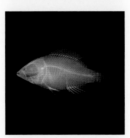

Page 135
Caquetaia myersi
Cichlid
LOCATION: Ecuador
ORDER: Perciformes
FAMILY: Cichlidae
USMN: 311348
COLLECTED: Unknown

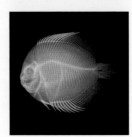

Pages 136, 137
Symphysodon aequifasciatus
Cichlid
LOCATION: Peru
ORDER: Perciformes
FAMILY: Cichlidae
USMN: 304451
COLLECTED: Unknown

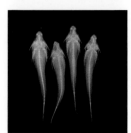

Pages 138–139

Plagiogrammus hopkinsii

Prickleback

LOCATION: California

ORDER: Perciformes

FAMILY: Stichaeidae

USMN: 44721

COLLECTED: 1893

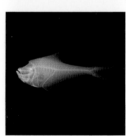

Page 141

Synchiropus

Dragonet

LOCATION: Hawaii

ORDER: Perciformes

FAMILY: Callionymidae

USMN: 314622

COLLECTED: 1967

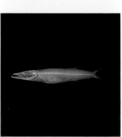

Pages 142, 143

Kurtus gulliveri

Nurseryfish

LOCATION: Papua New Guinea

ORDER: Perciformes

FAMILY: Kurtidae

USMN: 217310

COLLECTED: 1975

Page 144

Sphyraena

Barrracuda

LOCATION: Mauritius

ORDER: Perciformes

FAMILY: Sphyraenidae

USMN: 349831

COLLECTED: 1995

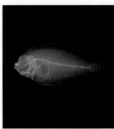

Pages 145, 146, 147

Engyprosopon xenandrus

Lefteye flounder

LOCATION: Hawaii

ORDER: Pleuronectiformes

FAMILY: Bothidae

USMN: 51687

COLLECTED: 1902

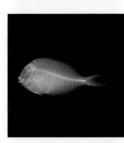

Page 146

Acanthurus sohal

Surgeonfish

LOCATION: Eritrea

ORDER: Perciformes

FAMILY: Acanthuridae

USMN: 342879

COLLECTED: 1969

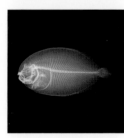

Page 148

Bothus maculiferus

Lefteye flounder

LOCATION: Panama

ORDER: Pleuronectiformes

FAMILY: Bothidae

USMN: 81683

COLLECTED: 1912

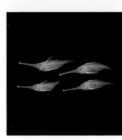

Page 150

Macrorhamphosodes platycheilus

Spikefish

LOCATION: Indonesia

ORDER: Tetraodontiformes

FAMILY: Triacanthodidae

USMN: 265189

COLLECTED: 1983

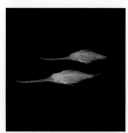

Page 151

Halimochirurgus alcocki

Spikefish

LOCATION: Somalia

ORDER: Tetraodontiformes

FAMILY: Triacanthodidae

USMN: 306615

COLLECTED: 1987

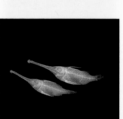

Page 151

Macrorhamphosodes platycheilus

Spikefish

LOCATION: Somalia

ORDER: Tetraodontiformes

FAMILY: Triacanthodidae

USMN: 306626

COLLECTED: 1987

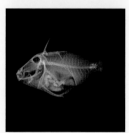

Page 152

Balistapus undulatus

Triggerfish

LOCATION: Wallis Island

ORDER: Tetraodontiformes

FAMILY: Balistidae

USMN: 374967

COLLECTED: 2000

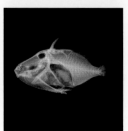

Page 153

Rhinecanthus rectangulus

Triggerfish

LOCATION: Philippines

ORDER: Tetraodontiformes

FAMILY: Balistidae

USMN: 113061

COLLECTED: 1909

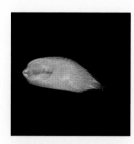

Page 154

Diodon holocanthus

Porcupine fish

LOCATION: Philippines

ORDER: Tetraodontiformes

FAMILY: Diodontidae

USMN: 228556

COLLECTED: 1978

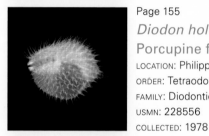

Page 155

Diodon holocanthus

Porcupine fish

LOCATION: Philippines

ORDER: Tetraodontiformes

FAMILY: Diodontidae

USMN: 228556

COLLECTED: 1978

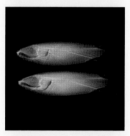

Page 157

Ranzania laevis

Mola

LOCATION: Jordan

ORDER: Tetraodontiformes

FAMILY: Molidae

USMN: 349206

COLLECTED: 1972

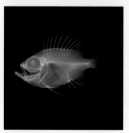

Page 158

Pristigenys alta

Bigeye

LOCATION: Alabama

ORDER: Perciformes

FAMILY: Priacanthidae

USMN: 358607

COLLECTED: 1997

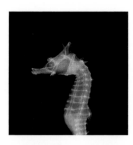

Page 160

Hippocampus sindonis

Seahorse

LOCATION: Japan

ORDER: Syngnathiformes

FAMILY: Syngnathidae

USMN: 49730

COLLECTED: 1907

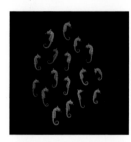

Page 162

Hippocampus zosterae

Seahorse

LOCATION: Florida

ORDER: Syngnathiformes

FAMILY: Syngnathidae

USMN: 176184

COLLECTED: 1951

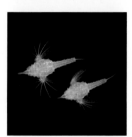

Page 164

Pegasus draconis

Seamoth

LOCATION: Philippines

ORDER: Gasterosteiformes

FAMILY: Pegasidae

USMN: 137201

COLLECTED: 1908

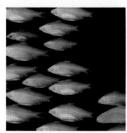

Pages 166, 168

Prochilodus magdalenae

Curimatid

LOCATION: Colombia

ORDER: Characiformes

FAMILY: Prochilodontidae

USMN: 76962

COLLECTED: 1916

IMAGE SOURCES

USMN = United States National Museum (Smithsonian Institution)

SAIB = South African Institute for Aquatic Biodiversity

ANSP = The Academy of Natural Sciences, Dept. of Ichthyology

SIO = Scripps Institution of Oceanography, Marine Vertebrates Collection

CMK = Private Collection of Maurice Kottelat

LACM = The Natural History Museum of Los Angeles County

WAM = Western Australian Museum, Dept. of Fishes

BIOGRAPHIES

Jean-Michel Cousteau

Explorer, environmentalist, educator and film producer for more than four decades, Jean-Michel Cousteau has used his vast experiences to communicate to the world his love and concern for the earth.

The son of ocean explorer Jacques Cousteau, Jean-Michel spent much of his life with his family exploring the world's oceans aboard *Calypso* and *Alcyone*. Honoring his heritage, Jean-Michel founded Ocean Futures Society in 1999 to educate and foster a conservation ethic for our water planet.

As Ocean Futures' leader, Jean-Michel serves as an impassioned diplomat for the environment, reaching out to the public through a variety of media. Jean-Michel has produced more than 75 films and received Emmy, Peabody, 7 d'Or, and CableACE awards. In partnership with KQED, a PBS affiliate, Jean-Michel is executive producer of *Jean-Michel Cousteau's Ocean Adventures*, a six-part television series that aired in 2006 on PBS and internationally.

Dr. Daniel Pauly

Dr. Daniel Pauly became a professor at the University of British Columbia's Fisheries Centre in 1994, after many years at the International Centre for Living Aquatic Resource Management (ICLARM). Dr. Pauly's work is dedicated to the management of fisheries and to ecosystem modeling. The concepts, methods, and software he codeveloped are in use throughout the world.

In 2001, he was awarded the Murray A. Newman Award for Excellence in Marine Conservation Research, sponsored by the Vancouver Aquarium, and the Oscar E. Sette Award of the Marine Fisheries Section, American Fisheries Society. He was named an "Honorarprofessor" at Kiel University, Germany in late 2002. In 2003, he was named one of UBC's Distinguished University Scholars and elected a fellow of the Royal Society of Canada (Academy of Science). In 2004, he received the Roger Revelle Medal from IOC/UNESCO, and the Award of Excellence of the American Fisheries Society. In 2005, Dr. Pauly received the International Cosmos Prize, a prestigious award granted by the Expo '90 Foundation of Japan, for research excellence with a global perspective.

BIOGRAPHIES

Dr. Lynne R. Parenti

Dr. Lynne R. Parenti joined the National Museum of Natural History, Smithsonian Institution, in 1990, as a curator of fishes and research scientist. Dr. Parenti received her B.S. in 1975 from the State University of New York at Stony Brook and was awarded her PhD in 1980 from the joint graduate training program in systematic biology between the American Museum of Natural History (AMNH) and the City University of New York. A native New Yorker, she developed an early interest in natural history and focused on vertebrate comparative anatomy while an undergraduate.

Dr. Parenti is past president of the American Society of Ichthyologists and Herpetologists (the first woman ichthyologist to hold that office), an elected fellow of the American Association for the Advancement of Science and honorary fellow of the California Academy of Sciences, serves on the National Academy of Sciences U.S. National Committee/DIVERSITAS, and is an adjunct faculty member at the George Washington University and San Francisco State University.

Sandra J. Raredon

Sandra J. Raredon was born in Nancy, France, and immigrated to the United States when she was ten years old. Her association with the Smithsonian Institution dates back to high school, when she participated on a summer dig in Israel with Smithsonian archeologists. She continued her studies in archeology, history, and Spanish at Madison College in Harrisonburg, Virginia, and then entered the archeology program at the University of Tennessee, Knoxville. In 1983, she was hired at the Smithsonian Institution's National Museum of Natural History, and five years later she became a permanent staff member of the Division of Fishes of the Department of Vertebrate Zoology, where she is a museum specialist. Since that time, she has radiographed 10,000 fish specimens representing hundreds of different species. (Below: *Eurithmus sandrae*, eeltail catfish, courtesy of the Western Australian Museum; *Cetopsis sandrae*, whalelike catfish.)

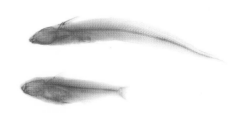

BIOGRAPHIES

Stephanie Comer

Stephanie Comer is a freelance photo researcher who has worked on a number of book projects with Visual Literacy INC. Formerly, she worked at *Wired* magazine as a researcher in the art department. Her previous museum experience includes working as exhibitions coordinator at The Friends of Photography, where she helped develop Look Again! Photography in the Classroom, an educational outreach program. In addition, she helped conceptualize and produce a series of innovative educational exhibitions that explored the history, science, and art of photography. Ms. Comer received her Master of Fine Arts degree in photography from the San Francisco Art Institute.

Deborah Klochko

Director of the Museum of Photographic Arts in San Diego, California, Deborah Klochko has over twenty years' experience in photography museums as an educator, director, and curator. Ms. Klochko has curated thirty exhibitions; was executive editor of *see,* an award-winning journal of visual culture; and is the founder of Speaking of Light: Oral Histories of American Photographers. Formerly the director of The Friends of Photography, located at the Ansel Adams Center, Ms. Klochko has also worked at the California Museum of Photography; the International Museum of Photography and Film at the George Eastman House in Rochester, New York; and the Prints and Photographs Division of the Library of Congress in Washington, D.C.

ACKNOWLEDGMENTS

We would like to thank Gerry Allen, Jean-Michel Cousteau, Rick Feeney, Merry Foresta and the Smithsonian Photography Initiative, Susan Jewett, Maurice Kottelat, Dan Meinwald, Lynne R. Parenti, Daniel Pauly, Sandra J. Raredon, Michael Rauner, Richard Rosenblatt, Mark Sabaj, Paul Skelton, Pam Stacey, and Jeff Williams.

Deborah Klochko
Stephanie Comer

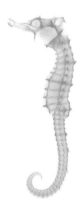